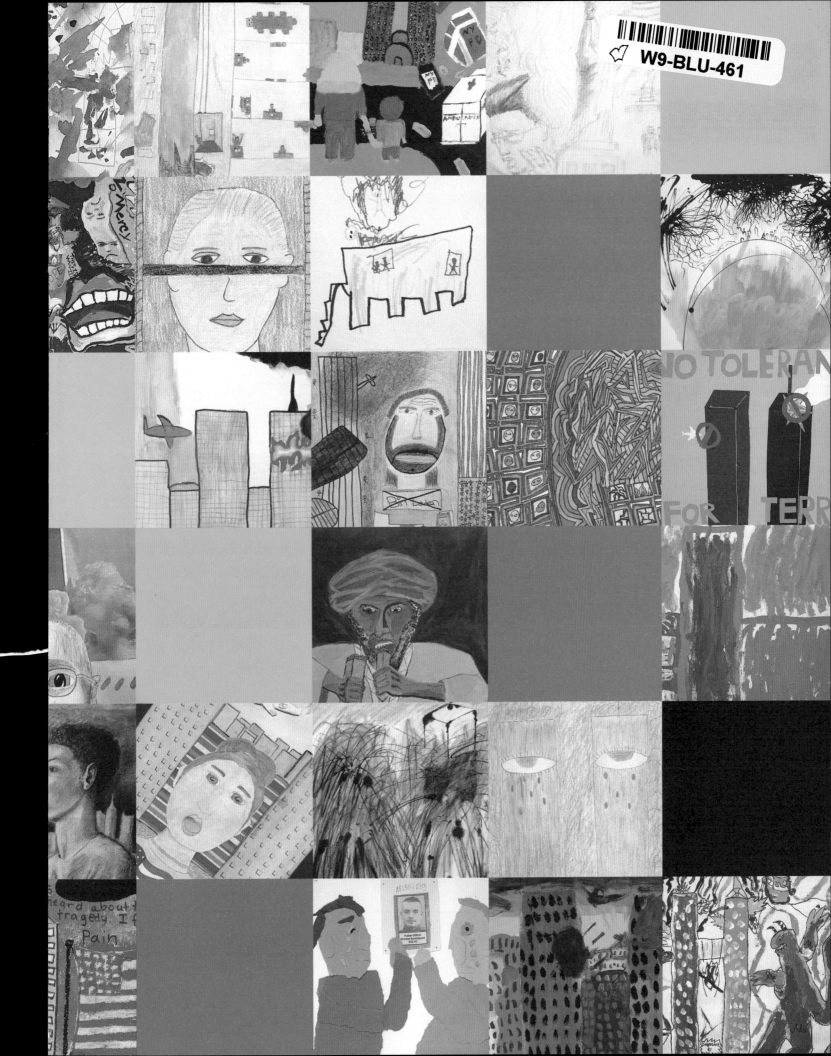

THE DAY OUR WORLD CHANGED

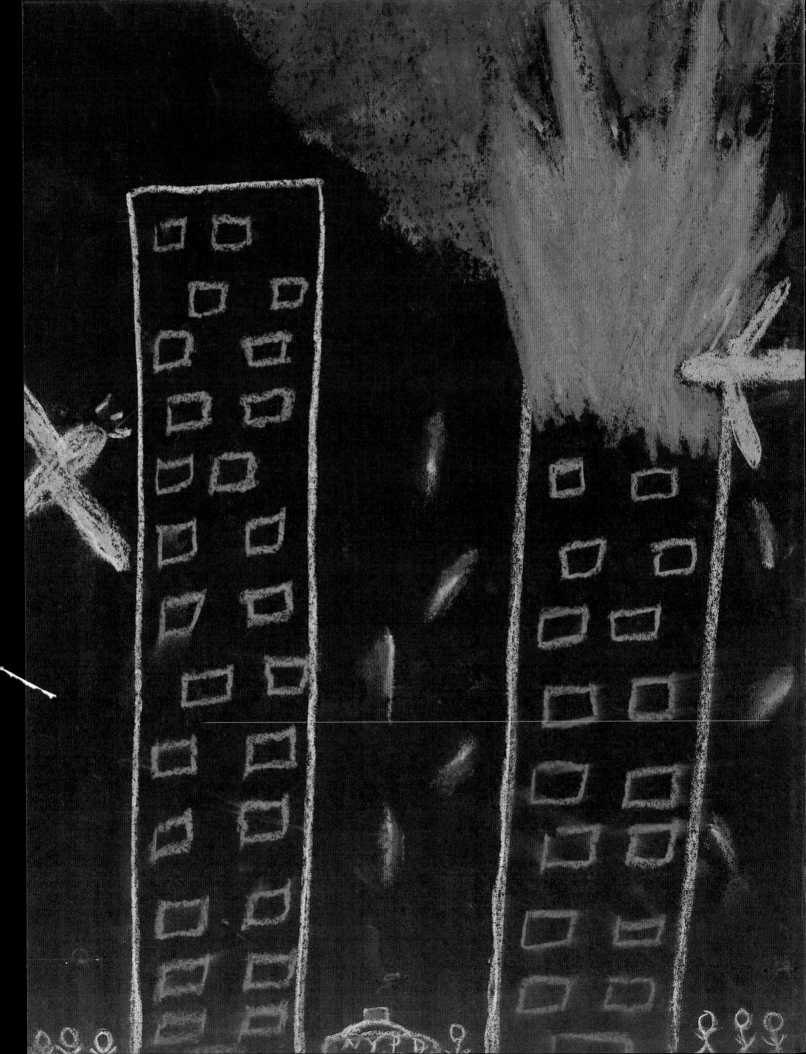

THE DAY OUR WORLD CHANGED
children's art of 9/11

Introduction by Rudolph W. Giuliani
Robin F. Goodman, Ph.D. & Andrea Henderson Fahnestock
Forewords by Harold S. Koplewicz, M.D. & Robert R. Macdonald

ESSAYS BY:

Debbie Almontaser, Arthur L. Carter, Senator Jon S. Corzine, Reverend Alan Gibson,
Robin F. Goodman, Pete Hamill, Sarah M. Henry, Imam Abdul Malik, Lieutenant Victor J. Navarra,
Governor George E. Pataki, Tim Rollins, Jane Rosenthal & Craig Hatkoff,
Rabbi Peter J. Rubinstein, and Senator Charles E. Schumer

NEW YORK UNIVERSITY CHILD STUDY CENTER & THE MUSEUM OF THE CITY OF NEW YORK

HARRY N. ABRAMS, INC., PUBLISHERS

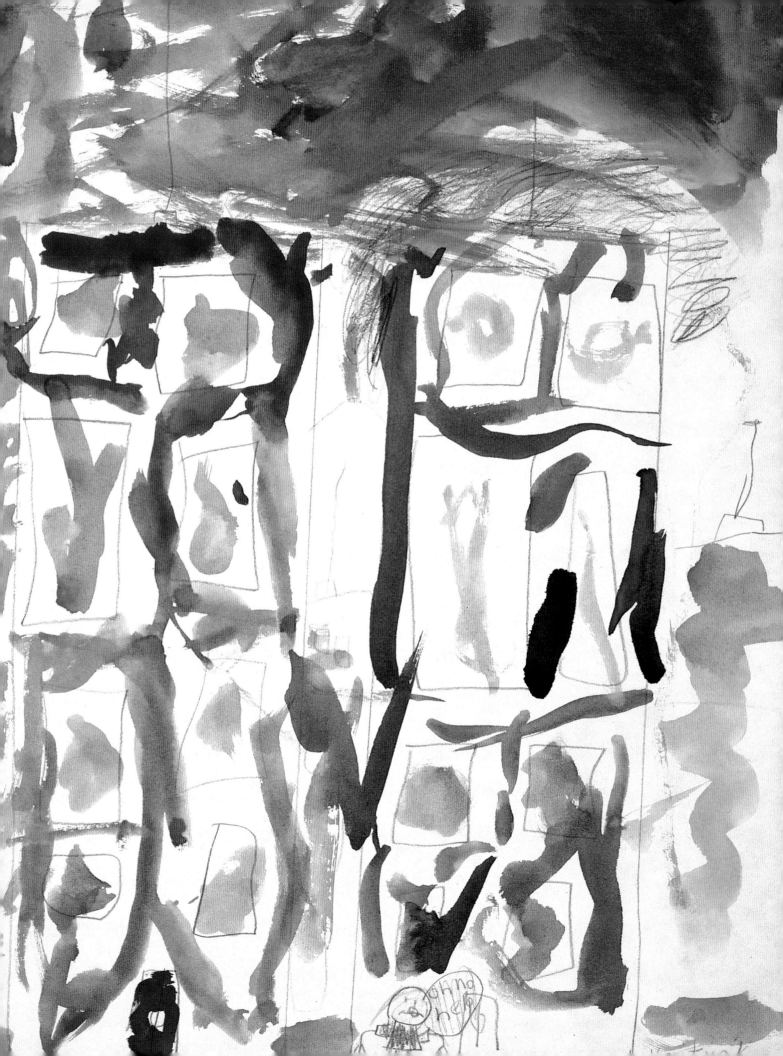

contents

THE DAY OUR WORLD CHANGED

| Kaitlyn Kovacs, 8 years old. **Untitled.** 17 7/8 x 12"

Dedicated to the children
of the New York area, but
most especially those who
lost a parent on 9/11.

Acknowledgments

A project of this scope and breadth required supreme effort, collaboration, and care on the part of many. Eric Himmel, Editor-in-Chief at Abrams, is a visionary and, just as important, a pragmatist. He understood the importance of this project and got on board immediately. We are grateful for the thoughtful and sensitive eyes of our jury members: Lisa Pevaroff Cohn, Miriam de Uriarte, Andrea Henderson Fahnestock, Robin F. Goodman, Diana Horowitz, Ashfaq Ishaq, Whitney Scott, and Linda Sirow. The art is also enriched by the personal commentary of our contributing authors: Debbie Almontaser, Arthur L. Carter, Senator Jon S. Corzine, Reverend Alan Gibson, Robin F. Goodman, Pete Hamill, Jane Rosenthal & Craig Hatkoff, Sarah M. Henry, Imam Abdul Malik, Lieutenant Victor J. Navarra, Governor George E. Pataki, Tim Rollins, Rabbi Peter J. Rubinstein, and Senator Charles E. Schumer. We are indebted to the teachers and families for bringing us the young artists who generously shared their feelings, thoughts, and art. We most especially thank former Mayor Rudolph W. Giuliani for writing the introduction to this book and even more for his strength and leadership in the aftermath of September 11.

The stunning results would not have been possible without the excellent organizational skills of Jennifer Rosenblatt and the assistance of Dellese Hanley, Sonia Lee, Anne Szelwach, and the editorial efforts of Anita Gurian. We thank Gail Mandel, our editor at Abrams, for being a sensitive taskmaster, our book designer Michael Walsh for his creativity, and our photographer Alan Zindman for being an artist. The collegial efforts of Sabeth Ryan Albert, Robert Balthaser, Ellin Burke, Catherine Collier, Jennifer Hirschowitz, Melanie Hoffman, Lavinia Mancuso, Monica Mercado, Patricia Ogden, Rebecca Schnall, Deborah Waters, and Kassy Wilson made this a successful partnership.

This rewarding institutional collaboration was made possible by Robin F. Goodman and Andrea Henderson Fahnestock. Our admiration and gratitude goes to them for making this exceptional book and exhibition realities. ■■▮▮

HAROLD S. KOPLEWICZ, M.D., Director, New York University Child Study Center

ROBERT R. MACDONALD, Director, The Museum of the City of New York

FOREWORD BY ROBERT R. MACDONALD

When terrorists attacked New York City on September 11, 2001, they cleaved a wound into the city's perception of itself and its sense of well-being. Hundreds of thousands of New Yorkers witnessed the attack and its aftermath in person, and millions more in the city and throughout the world watched television in disbelief at the horror of the loss of almost 3,000 innocent lives. There had been no comparable cataclysmic moment in the city's almost 400-year history.

In the days and months that followed September 11, men and women, adults and young people groped to make sense of what the tragedy meant to them personally and collectively. Scholars, journalists, business leaders, politicians, clerics, and ordinary citizens expressed their shock, sorrow, anger, and hopes for a future that remains uncertain. Their often eloquent words will provide future generations valuable insights into how we understood and dealt with the calamity. Equally expressive have been the contributions of professional and amateur visual artists. Some of these artistic works will be forgotten by all but their creators, while others will surely endure. Whether verbal or nonverbal, the struggles to make sense of September 11 have been more than a documentation of what happened and our response; they have been integral to the healing process.

This book and accompanying exhibition are products of a unique collaboration between The Museum of the City of New York and the New York University Child Study Center. The center solicited children's artwork made in response to September 11 by reaching out to parents and to public, private, and parochial schools in the New York metropolitan region. The participating artists range in age from five to eighteen. Their creations explore themes of violence, heroism, fear, hope, sadness, patriotism, and prejudice. A jury appointed by the museum and the center, composed of artists, curators, art teachers, mental health professionals, parents, and students, reviewed hundreds of submissions and selected eighty-three pieces for inclusion in the exhibition and book. Commentary and personal essays by prominent New Yorkers from a variety of disciplines accompany the images.

The Day Our World Changed presents the creative witness of young people to September 11. Unencumbered by the caution and inhibition brought on by adulthood, these young New Yorkers have movingly expressed the pain, fear, insight, and resilience often hidden in the words and works of more mature participants in the shared drama of the day. In so doing, they have fashioned a distinctive, historical record. It is hoped that these young artists also have found their efforts to be salutary as they, their contemporaries, and adult New Yorkers remember and deal with the day our world changed. ■

THE MUSEUM OF THE CITY OF NEW YORK is a private, not-for-profit, educational corporation founded in 1923 for the purpose of presenting the history of New York City and its people as a significant learning resource. The museum advances its mission through exhibitions, educational activities, and publications and by acquiring, preserving, and documenting original cultural materials that reflect New York City's history. In fulfilling its mission, the museum provides New Yorkers and visitors an understanding of the individual and shared heritages that have traditionally characterized New York City and the sense of times, place, and self that is essential for the well being of all communities. The museum's web site is www.mcny.org.

"I painted the World Trade Center as it was because I wanted to remember it that way. I used to look at it every day from my window. It was September 11th and all was quiet. Then a crash. Then another. It fell to the ground. Soon after, the other followed the first. They held up the flag. Recited the Pledge. But nothing could replace what we had lost. What New York had lost. What America had lost."

| Chloe Sharfin, 10 years old. **Untitled.** 17 15/16 x 23 3/4"

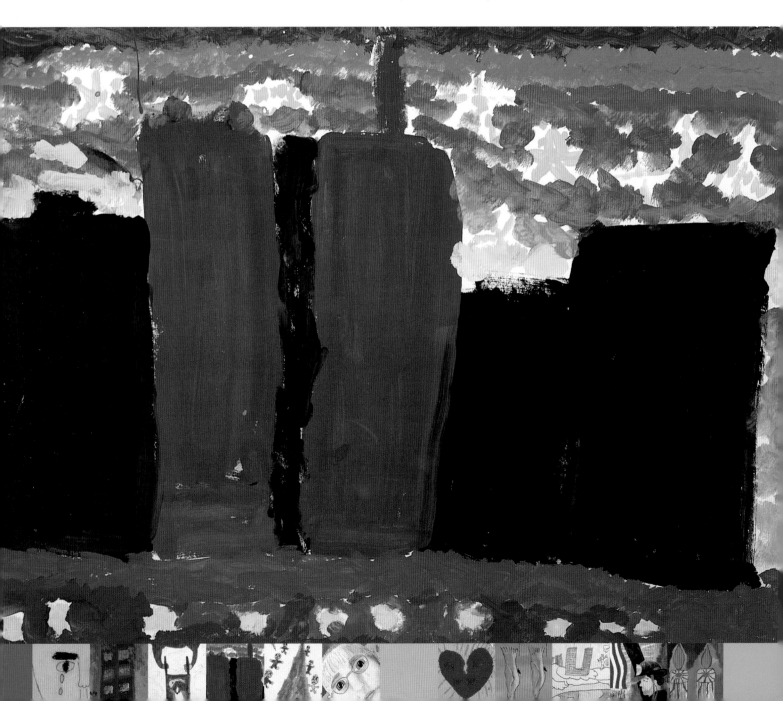

FOREWORD BY HAROLD S. KOPLEWICZ, M.D.

On September 11, 2001, the unthinkable occurred: our nation was stabbed in its symbolic heart. On that day thousands of Americans were killed; twin symbols of strength, progress, and economic freedom were destroyed; and the Pentagon, our military nerve center, was attacked.

A year later we are trying—and, fortunately, most of us are succeeding—to settle into a new sense of normal. A vital part of this adjustment is the realization that our children are now growing up in a different world from the one we knew. In a single day, the illusion of our nation's invincibility was shattered for them. How they handle this new sense of vulnerability and, more importantly, how we as adults help them find their way, will have a tremendous influence on our country's future.

Recognizing that the children most affected by this tragedy were the ones closest to the event either physically or emotionally, the New York University Child Study Center has collaborated with New York City's Board of Education and emergency service departments to provide a broad range of services for them, their parents, and their teachers. However, the impact of these attacks affected children everywhere. We felt that if we could give children from the New York metropolitan area an opportunity to express themselves in the aftermath of the event, it would not only help them come to terms with their reactions, but it would also help adults to better understand their feelings. In New York, across the country, and, in fact, around the world, we can all benefit from seeing their impressions, thoughts, and images reflecting the tragedy of September 11, 2001. Now a year later, this artwork helps us remember, grieve, and heal.

The idea for this project evolved from seeing the immediate outpouring of art created by children affected by the tragedy. The work sprung up spontaneously, adorning building facades, storefronts, fire and police stations, and the walls of emergency assistance facilities throughout the city. Instinctively and professionally, we knew that the children felt most comfortable revealing in their art what they witnessed and experienced. Their own documents of the day needed to be understood and preserved.

The NYU Child Study Center has had experience with a previous traveling children's art exhibition and book, *Childhood Revealed: Art Expressing Pain, Discovery & Hope*. The project presented the artwork of psychiatrically ill

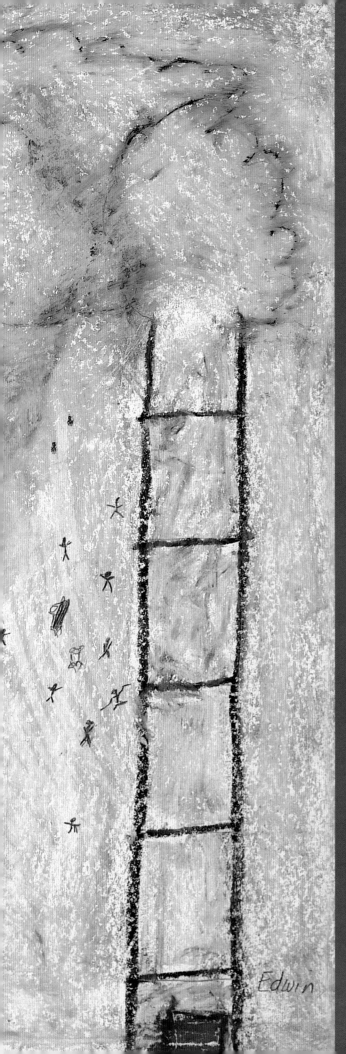

| Edwin, 10 years old. **Untitled.** 16 $^{15}/_{16}$ x 10 $^{7}/_{8}$"

children and teenagers, and from it we learned how powerful such work could be, both for the young artists themselves and for its audience. The *Childhood Revealed* exhibit has traveled to twenty cities, has had a dramatic effect on adults, and has served as a starting point for discussion with students about mental disorders: how real, how common, and how treatable. We hope that the present exhibition and book will likewise stimulate the discussion of difficult subjects, feelings, and reactions that have perhaps not yet been adequately explored or accepted, as well as of children's shifting perceptions of their world and their role in it.

We think you will be as moved as we were by these profound images of violence, terrorism, and destruction, which are countered by equally powerful expressions of patriotism, strength, and hope. We ask that when looking at this work, you keep in mind that the artwork was solicited from average, normal children. Also, consider the intensity of the experience of 9/11 on children who were already suffering from anxiety or depression, those who were evacuated from their schools, or those who lost a parent. We urge you to use this exhibition and book as an educational opportunity. With so many affected in so many ways, we all have a responsibility to learn more about the warning signs of depression, anxiety, and post-traumatic stress disorder (our website, **www.AboutOurKids.org** provides parent-friendly information about these disorders.) We owe that to our children.

In this effort, we have been honored to partner with The Museum of the City of New York, an institution dedicated to our city, its history, and its future. In preparing this exhibition, we received over eight hundred submissions, and our jury selected eighty-three pieces for inclusion. While the art featured in the exhibit is representative of all the work, we want to have the opportunity to share all of the remarkable and striking submissions with the public. Therefore, we have jointly established a new website **www.TheDayOurWorldChanged.org** to exhibit the balance of the artwork.

We wish to thank all of the artists who contributed their work, and we believe you will find their pieces both provocative and enlightening. On September 11, 2001, we know that the world changed for us all. In this book and exhibition, New York's children poignantly show how it changed for them.

INTRODUCTION BY RUDOLPH W. GIULIANI

On September 11, 2001, I had been New York City's Mayor for almost eight years. As I arrived at the World Trade Center that morning, I remember thinking, "I can't believe this is happening." I thought I had witnessed every conceivable disaster, but I had a difficult time understanding these attacks. The enormity was hard to grasp. So I can only imagine how it affected the children of New York City and beyond. Making sense of these events is challenging for anyone. But it is particularly hard for children, who sadly have to learn that the world is not always a safe place, that there are bad people out there who seek to do harm to innocents.

Art is one tool children can use to help them understand the events of September 11. The great Spanish artist Pablo Picasso said, "Through art we express our conception of what nature is not." He meant that the world can be difficult to comprehend. Art allows people to make sense of the world. Children, in particular, often demonstrate a remarkable ability to capture complicated feelings through drawings and paintings. Those drawings and paintings not only help the children who create them understand their world, they do the same for those who view them.

When people ask for advice about how to talk to children about what happened that day, I use the same approach I always do: honesty and frankness are the best policy. Hiding from the reality only deprives children of the chance to learn about the complexities of our world. But all explanations have to be given in the right way, in a sensitive way. How appropriate then that this project was created by the New York University Child Study Center, an institution dedicated to expanding our knowledge about child mental health, and The Museum of the City of New York, which is dedicated to preserving the city's history.

On September 11, children saw human beings at their very worst. The cruel, senseless violence of nineteen terrorists and the cowardly acts of those who backed them will forever remind us that the world can be a frightening place. Children also saw human beings at their very best that day. They saw New York City police, fire, and emergency personnel heroically rush to the scene to lead one of the biggest rescues in history. At least 25,000 people were saved because of the bravery of these men and women. It wasn't just the professional heroes who demonstrated extraordinary courage and character. At Ground Zero, I saw with my own eyes the evacuation of thousands of people after the planes hit the World Trade Center towers. Sure, people were hurrying to safety. But they didn't do the one thing the terrorists expected them to: panic. Regular, everyday Americans acted calmly and helped each other safely exit the buildings—and in so doing, they held down the number of casualties dramatically.

Ready or not, the children of New York City—indeed, all American children—grew up very quickly on September 11. As hard as it is to accept the terrible events of that day, it's better that all of us, even our children, understand the challenges our world faces. Ultimately, the more we know about those challenges, the better our chances of preventing future attacks like the one we endured on that awful September morning. That our children can express their hopes for a peaceful world in their drawings encourages us all to look forward with optimism.

The Day Our World Changed: Children's Art of 9/11

ROBIN F. GOODMAN, PH.D., A.T.R.-BC

THROUGH CHILDREN'S EYES

Special x-ray cameras for examining what children saw and felt on September 11, 2001, don't exist. The art in this collection, created in the first four months after 9/11, does, however, provide a snapshot of children's raw and immediate reactions. A private corner of the children's world of uncensored memories, thoughts, and feelings is exposed here in their drawings and paintings. The media was relentless in displaying the realistic drama, but the children's art yields a different kind of immediacy and strength to the reality. There are narrative pieces, illustrating detailed occurrences of the day. Other art is dramatic, transcending the literal experience and imparting the personal that communicates the universal. Viewers will most likely be compelled to linger over the pictures to fully grasp all that the artists share. The touching details—a wrinkled brow, a weary rescue dog, a sea of lighted candles—that these children absorbed and use to signify the meaning of the day are reminders of the tragedy.

The event was so public, and particular news images so common, we all think that we know what happened. We were bombarded with the "objective truth." But I am struck by just how private the art in this collection is. Art activities "invite the creation of a world that is egocentrically organized. Each element in the child's work contains part of himself" (Kramer). The pictures from these children show the event as an individual experience, a characteristic that was easily lost in all the repeated, graphic photographs and videotapes.

CHILDREN'S ART CAPTURES AND CAPTIVATES

Children and artists have ready access to the imagination, enabling them to express the fantastic, inconceivable, or unspoken. Adults easily recount stories about events, but children, in their art, capture feeling. Often bound by social convention, adults hide who they are or become self-conscious about how they draw. As children look to adults for acceptance, strength, reassurance, and guidance, they quickly learn what is expected. In time, children and adults may come to say, "I'm fine," although it may be insincere. But in their art, children can be more fearless; they are often their most direct, curious, and honest. Looking at this art, adults can secretly feel things they may be afraid to show or tell.

Art provides an unparalleled vehicle for children to express themselves and an effective tool for parents, teachers, and therapists. Creative activity is incredibly powerful, especially for responding, or as an antidote, to a destructive act. As a psychologist and art therapist, I have seen children transformed by the process of creating as well as by what is accomplished in the finished product.

Children's age, intellect, skill, background, and personality all influence the form of an image. There is an expected progression of children's basic artistic development. But we must discover and tease out those elements that go beyond the typical and are enduring as individual traits. To illustrate September 11, many of the youngest children easily drew the obvious tall buildings, jet planes, and fireballs. Having mastered the ability to draw the classic four-sided shape of a tower or the straight lines of a flag, they made what television and newspapers had imprinted on

their minds. But they were also capable of discharging their own strong emotions, or what was felt from those around them, with dense color, swirling chaotic lines, and tiny stick figures dwarfed by the towers, shouting, "Help!" Older children produced more studied statements, using stylized metaphors or expected stereotypes to symbolize feelings. The monochromatic, pencil drawings were extremely effective at capturing a vivid array of colorful thoughts and feelings. These pieces underscore the complexity of the issues and solutions, concepts not easily reduced to black and white, not definite or absolute. The range of affect evoked is quite remarkable—sadness, pride, anger, and hope among them—and art allows these powerful feelings to be externalized. Some art is arresting in its outward calm, like a deafening silence. Other art quickly recalls the chaos and shock of the day.

The art also shows children's empathy, a capacity to feel for those who were in harm's way as well as for one's self. And the resiliency of children appears loud and clear. One child sprinkled magic gold dust on the skyscrapers, while another revealed a wish for love and unity with clasped hands. We would like to keep children innocent from the ugliness of the world, but their art says this is not possible. The question is how to tell, not if to tell. Children are usually most afraid of what they don't know or what is kept secret. Yet they need to learn, be aware, be prepared, and develop their own internal resources. Remarkably, they can know what happened, confront it in their art, and continue on the normal trajectory of childhood tasks and joys, while maintaining hope for the future.

PERSONALIZING REALITY

Often children's art stems from their imaginations; here the impetus was reality. Ground Zero instantly became a designated area of international attention, but the art suggests that New York is more than just two tall buildings. Panoramic views from across the river show the vastness of the city and the widespread nature of the impact. Close physical or emotional proximity alone did not predict what children saw or how they were affected.

From the hundreds of artworks submitted for this project, some common themes emerged.

THE ATTACK ON THE TWIN TOWERS: SHOCK, ANGER

Not all the children were eyewitnesses to the plane crashes. But incorporated into their consciousnesses were impressions from images splashed across the news. The relative proportion of floors above and below the planes' points of entry, and people dropping into the air, seem, unfortunately, remarkably accurate in the art. A cutout phrase pasted next to a photo seems to summarize the spontaneous, unpredictable, and disorganized thoughts and emotions that must have been running through children's minds. Other more straightforward, spare, cut-paper pictures reflect clear statements about unsettled feelings.

THE CITY MOURNS: SADNESS, FEAR

With sorrow, some children reveal the quiet mourning felt by many. With distinct personalities, passions, hair color, and dress, we see the kaleidoscope of differences that separate individuals. But equally apparent is how the horror of the event unites even the most dissimilar.

HEROES & HELPERS: COMPASSION, COOPERATION

The magnificent sacrifice of the fire, police, medical, and rescue workers made us all feel grateful and perhaps guilty for ever taking them for granted. The everyday and official heroes were ever present in the art. The smaller, independent acts of kindness and goodheartedness, epitomized by a child's visit to a firehouse, set the example for a generation of children who must learn, if they have not already, to be compassionate and tolerant.

MEMORIES & TRIBUTES: LONGING, HONORING

With conviction, some children immortalized the day and those who died with fields of flowers and candles. Others depicted strong replacement buildings. And still others portrayed the World Trade Center towers as mighty lone structures, in hindsight perhaps a forewarning of their vulnerability. For some, memories of 9/11 reawaken thoughts of a once strong and familiar anchor. Commenting on his drawing, one child said, "Whenever we came back from a trip, I saw the towers and knew I was home."

HOPE & RENEWAL: SYMBOLS, PATRIOTISM

Within hours of the attack, star-spangled flags blanketed streets, homes, and cars. These symbols are familiar, but the children found ways to make them their own. The banners and Statues of Liberty images identify the nation to which we belong and can provide shorthand for accumulated feelings. They say, "I am an American," "I am proud," "I cannot be hurt," "I have hope."

Whether the twin towers, the national flag, or a self-styled emblem, "symbols restore a sense of unity by integrating and connecting emotions, perceptions, and thoughts not previously brought into juxtaposition and, in so doing, create a complex subjective experience that is deeply moving and cathartic" (Lewis and Langer).

MEMORY: A FAINT WHISPER OR LOUD CLAP

Memory is kept alive in the making and viewing of art. The creator acts as both participant and audience when retrieving what was merely unformed thought and making it real. Remembering a burst of flames, then picking a red oil pastel to draw it, requires access to an inner image and choice in its expression. The process can enable one to express and accept confusing and perhaps terrifying feelings. Once completed, the piece offers distance between the artist and the subject matter. Ultimately, the result can reveal the liveliness of the original thoughts and remnant sensations. The art then has the power to provoke a re-experiencing and confronting of the original event.

In expressing what has passed, especially when it was troubling, children can be helped to confront and ultimately cope with the past and develop inner resolve to guide them through life. Children and adults viewing these familiar scenes will have a similar experience. "Art does not communicate meanings, it generates them in receptive minds" (Rose).

Sharp details are called to mind upon hearing the phrase "9/11." Where we were, what we did, whom we were with, and how we felt when we saw or heard the news can be recalled with excruciating clarity. The mind and body respond in both astonishing and predictable ways to trauma. The brain registers stunning idiosyncratic scraps of the event. When someone dies, memory becomes precious, an often-welcome companion. We cling to prized, personal memories and long to recall someone's

particular laugh, a singular outing, a favorite perfume, and a sage piece of advice. Memories survive, so we can extract the past in the present. Some memories are painful, and we ache for the power to delete them forever. Some are cherished. They comfort us; we yearn to relive them at will.

We may not realize what lies in memory storage. Our heart pounds as we stand on a familiar street corner or smell an eerily identical scent. It causes us to recall with fresh vigor a long-past experience. It will be like that with much of the 9/11 reminders. We will be fooled and relieved that we have forgotten, until something unexpected makes us feel a faint or quick rush of recognition. Avoiding the fresh episode is not the goal. Rather, learning how to cope and control its effect, possible through art, is how mastery and strength evolve.

ART AS A TIME CAPSULE

The children's art makes clear there is no right or wrong way to feel. There are no strict timetables or stages to conquer while moving on. The majority of children rebounded quickly, while others needed more time to restore their sense of safety, security, and trust. We can be encouraged by the strength and optimism demonstrated in this art. Children can—and do—jump over, go through, and get around life's obstacles.

We want children to know that their voices are important and that art is an extraordinary way to give voice to concern. We want adults to see what children may not put into words. We want parents to recognize the effect of trauma and death on children. And we want parents to find ways to talk to children about tough topics, perhaps starting with, "Tell me about your picture."

We know the past, we saw what happened. The future will be shaped by children like the ones represented here, often now referred to as the 9/11 Generation. For these children, the question, "What would your life have been like without 9/11?" has no possible answer. They can tell us how it was before the attacks, but they cannot subtract its effect from their lives going forward. It is their history, and their art provides a document of its impact. The children themselves will leave the official mark of the disaster's influence. Their art reveals memories of dramatic sights and feelings as well as an equally strong sense of pride, loyalty, and hope. Together, their images and emotions can propel them to change the world for the better.

As the days and years pass, the art in this book will assume new meaning. Like many generations of adults before us, I hope the generation who experienced 9/11 will use what they learned to change a potentially troubling course of history. This collection of art can serve as a lighthouse, illuminating a dark event in time. Ideally, the children will go forth down a brighter path.

Kramer, E. Art as Therapy with Children. New York: Schocken, 1975.

Lewis, L., and Langer, S. "Symbolization in Psychotherapy with Patients Who Are Disabled." American Journal of Psychotherapy: 48, no. 2 (1994).

Rose, G. Necessary Illusion: Art as "Witness." New York: International University Press, 1995.

Children as Witnesses to History

SARAH M. HENRY, PH.D.

Children are among history's most elusive witnesses. Museums and libraries are full of objects and documents that appear to tell the stories of childhood but are actually the creations of adults. The books, toys, clothes, and child-rearing manuals that inform what we think we know about childhood tell us much more about what society wanted children to be than what children actually saw, heard, believed, or felt. Thus children are more often than not the observed, rather than the observers, of history.

This gap in the historical record troubles historians of childhood and leaves the rest of us with a seriously impoverished understanding of our own history. For when we do have the opportunity to listen to children, their testimony is powerful. And art is one of the most compelling ways children have of expressing what they have experienced. Children's artistic

responses to such a cataclysmic event as the attack on the World Trade Center are therefore important not only as emotional testimony, but also as significant historic documents in their own right. They are inherently historical because they preserve and present a perspective that deserves to be honored and remembered.

In modern times we have become more attuned to hearing children's voices. After all, Anne Frank, one of the twentieth century's most celebrated witnesses to history and its horrors, was a child. However, through most of the history of earlier centuries, children's observations were—like childhood itself—less valued. Indeed, some historians argue that for hundreds of years, childhood was not understood in the Western world as a distinct period of life. Rather, children were seen at best as adults in

training and at worst as the untamed incarnations of mankind's sinful nature. In addition, low literacy rates made the experiences of all but the upper levels of society, adult or child, difficult to trace through conventional historical sources. Small wonder that little survives from the hands of generations of children beyond scattered letters or diaries, the odd sampler, or the occasional school copybook.

Historians have made something of a sport of debating when in history "childhood" was discovered, but it is clear that by the last quarter of the eighteenth century something important had changed in the way that many adults viewed children in the United States, and new opportunities emerged for hearing children's voices. Increasingly, childhood was seen as a special time in life, to be nurtured and treasured for its own sake. As a result, we have many more surviving objects and writings made by and for children from the 1800s than from earlier generations. This change came about for a number of reasons, some strongly

intellectual and others more the products of the social and economic changes of the nineteenth century. Nineteenth-century Americans were influenced by the legacy of the writings of two European philosophers who had argued that childhood was profoundly distinct from adulthood. English political philosopher John Locke viewed children as tabulae rasae, or blank slates, which could be filled with an infinite variety of scripts, while French philosopher Jean-Jacques Rousseau argued that children were innately pure and free of sin. Their views contributed to a romanticized vision of the innocent child that is most closely associated with the Victorians. This emotional, rather than economic, reckoning of childhood's value was reinforced by the fact that children were at this time becoming less important as part of the household workforce, at least in middle- and upper-class urban homes.

| Emma Larson, 12 years old. **Remember** (detail). 17 ⅞ x 24"

Other changes in this period opened additional opportunities for children's voices to be heard in ways that could prove quite revealing. The nineteenth century saw a massive transformation of the nation's economic, transportation, and communications systems, as the country became more interconnected, more commercial, more modern. The burgeoning popular press, the growing rates of literacy, and the increasingly market-oriented economy fostered the proliferation of literature, including works created especially for children that emphasized moralistic fables less and entertainment more. While these were obviously the products of adults, the penny press occasionally opened its pages to children's voices. Some of the popular children's magazines, including Robert Merry's Museum (starting in 1841) and most famously St. Nicholas (starting in 1873), welcomed letters and contributions from their youthful readers. The surviving issues of these periodicals offer a welcome opportunity to see the world of

the past through the eyes of a child. Children used their letters to comment implicitly or explicitly on the political events, social mores, and private lives of their day. The letters often picked up on aspects of life that adult observers would overlook, and they unconsciously show readers a century and a half later how the great historical events of the day mingled with the lives of ordinary people. Added to the personal diaries and letters of nineteenth-century children, these provide an interesting record of history through young people's eyes, but one that still emphasizes the older, literate, and educated child.

With the birth of the social sciences in the late nineteenth century, children's perspectives finally began to be actively studied, collected, and ultimately preserved as part of the historical record. Inspired by the new stress on science that was in part a legacy of Charles Darwin's work on evolution, social scientists focused their attention on human society. Sociologists, psychologists,

anthropologists, economists, social workers, and others studied children as part of their efforts to collect data about social problems and social conditions. Changes in educational philosophy—including the increasing success of the nineteenth-century kindergarten movement and the advent of the progressive model of education advocated by American philosopher John Dewey and others—encouraged children to make their own meaning and taught teachers that their role was to draw out ideas from their students rather than to mold and shape young minds and characters.

Opportunities to hear a broader cross section of children's voices expanded in the twentieth century, which Swedish educator Ellen Key declared the "Century of the Child" even before it officially began. While in many ways the century fell far short of its promise of elevating the condition of children around the world, it did turn far more attention to children, their development, and

their understanding of their own lives. Perhaps most critical in unlocking the historic voices of children were the new ways of looking at children's art and art education in the early twentieth century. As long as children were considered either imperfect little adults-in-the-making or innocent incarnations of purity, the art that they made was either disregarded or sentimentalized. But the influence of progressive educators, the revolution of modern art seen at the 1913 Armory Show in New York City, and particularly the popularization of Sigmund Freud's theory of the unconscious, led to new ways of looking at art and children's relationship to it. New techniques, like finger-painting, were embraced to encourage art as self-expression. By the 1920s and '30s, the fields of art education and art therapy embraced the idea that children's art was to be valued on its own terms.

Although the main purpose of encouraging children to make expressive art was not to document history, that was sometimes

| Emma Larson, 12 years old. **Remember** (detail). 17 ⅞ x 24"

the outcome. By valuing children's art enough to encourage its creation and preservation, art therapists and educators discovered a new way in which children could act as witnesses to history. Through an art therapist's eyes, children's images may show what is poignantly universal about childhood and how children react to events; for a historian, children's images reveal what is specific and historical in their life experience. For example, Australian art educator Frances Derham collected drawings by Russian students in the 1930s that depicted collective farms, while her young Aboriginal artists in the outback drew scenes of pig hunting and the work of missionaries. The young people's work she gathered in Depression- and war-torn Europe showed ruined villages and bombed-out buildings. In the Terezin "model ghetto" in Czechoslovakia, Friedl Dicker-Brandeis brought in art materials for the Jewish children interned there, awaiting deportation to the death camps, and they used them to produce moving and bittersweet evidence of hope in the face of utter despair. These images are all the more poignant and immediate precisely because of the familiar "childishness" of their technique. The twentieth-century use of children's art gave voice to the voiceless in ways that help preserve aspects of history that would otherwise be lost.

It may seem strange to speak about history being lost in the face of the almost overwhelming volume of material that exists related to the events of September 11, 2001. But historians are just beginning to appreciate fully the importance of children's experience, not only as witnesses to history, but as shapers of it. What happens during childhood not only affects the individuals involved; it affects the course of history. Generations are shaped by people who lived through certain historical events at the same stages of their lives. People who experienced the Depression—or World War II, or the Vietnam War, or the prosperity of the Cold War Era—as adults carried away very different experiences and lessons from these events than did those who lived through them as children.

It is far too soon to say how profound the historical effects of the shared experience of the cataclysm of September 11, 2001,

will be. Still, the children who lived through that day will continue to be powerful voices of history, and not only because they are destined to be the "last witnesses"—the ones who will survive the longest to bring the memories of that day and its aftermath forward to coming generations. Their writings and their drawings help to capture for posterity some of what happened that day. These events are so immediate in our memories that it seems hard to imagine a time when they will retreat into an abstraction of "history." But it takes only one look at a child's drawing from Terezin or from the Australian outback in 1939 to realize the power of art to animate and make real an event that has become distant and even abstract through the passage of time. This is the power of first-person testimony—it reminds us of the physicality, emotionalism, and actuality of history. Hundreds of generations of children's voices have been lost forever, leaving their experiences and their history unspoken and unremembered. To save these documents of our own era now is a profoundly ethical act, one that ensures we bear witness for posterity.

It is also too soon to say precisely what insights into our own reality future viewers will draw from these children's drawings made in the aftermath of 9/11. For the moment, they speak to us as documents of our own history as much through their mere presence as through their content. It hurts us that children had to make these images. In our culture children are supposed to be where history is not—in a cocoon of safety circumscribed by family and school. And yet, for all that we do to protect our children from history, we cannot succeed. The drawings of New York's children after September 11 remind us that our children, like us, do not and cannot inhabit safe, purely private and personal worlds. They navigate public and ultimately historic spaces. And in the end, although the world of children is not the world of adults, and their 9/11 was not our 9/11, for a moment on that day we were all children, put at the mercy of others, subjected to forces beyond our control and in many ways beyond our understanding. That the actual children among us could find hope and redemption amidst the pain and sorrow in those events is a beacon for us all.

| Emma Larson, 12 years old. **Remember.** 17 ⅞ x 24"

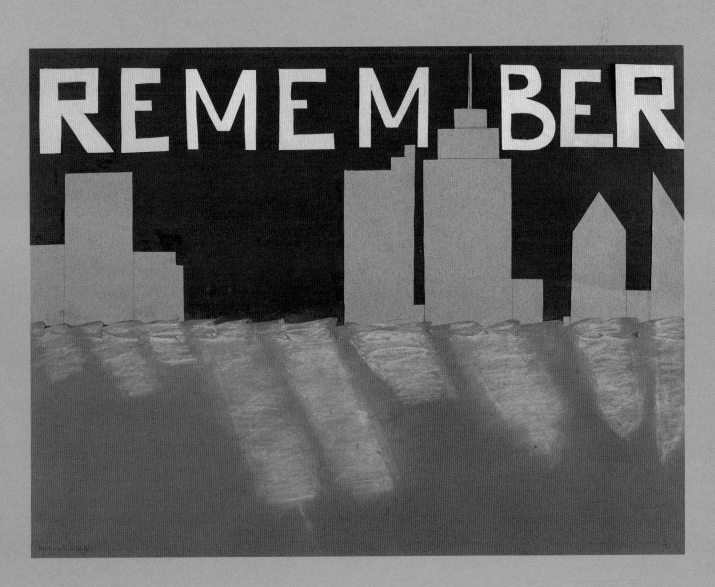

THE ATTACK

Charlotte Lockhart, 14 years old. **Untitled.** 23 ⁷/₈ x 17 ⁷/₈"

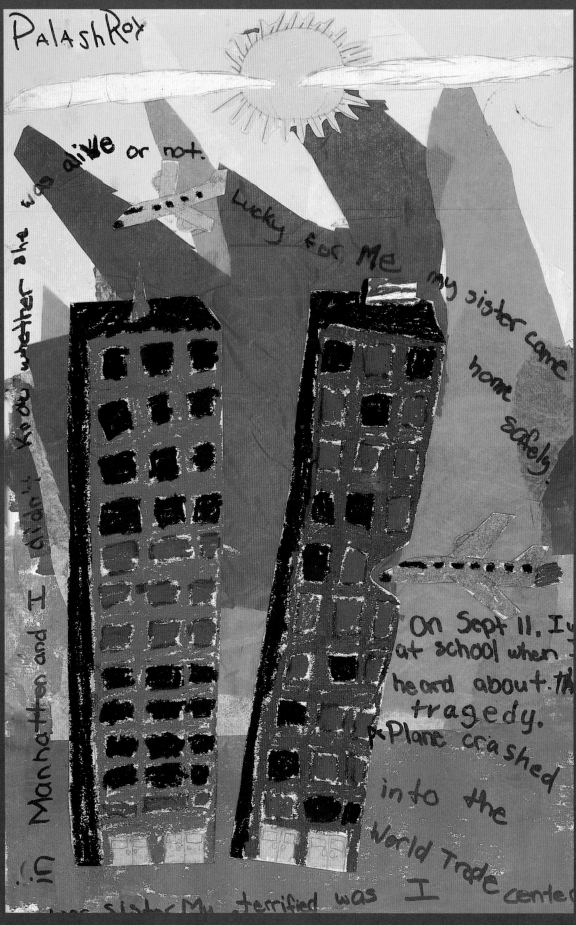

PalashRoy

alive or not. Lucky for Me my sister came home safely.

in Manhatten and I didn't know whether she was

On Sept 11, I y at school when I heard about th tragedy. Plane crashed into the World Trade center

sister My terrified was I

| Palash Roy, 11 years old. **World Trade Center Tragedy.** 11 5/8 x 17 1/4"

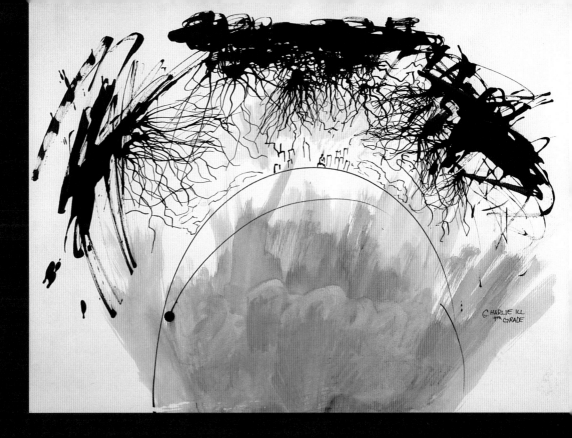

CHARLIE ILL
9TH GRADE

"I remember sailing in Long Island Sound and always recognizing New York City by the Twin Towers. The Towers always gave a sense of security by the way they stood, taller than all the other buildings. They stood so proud, immense, and gigantic, boasting the achievements and strength of America, symbolizing New York City. On September 11, 2001, the attack on America brought sadness and grief to my school. Several of my classmates had friends and loved ones who worked in and near the World Trade Center. Despite knowing that the towers were hit, I did not feel that anything was missing from my life until I saw it for myself. When my sister and I arrived home, we rode our bikes to the Connecticut shore and looked across the Sound. We saw smoke from the debris where the towers once stood. Silence struck us as we stood in shock. New York without the World Trade Center is like Paris without the Eiffel Tower, Egypt without the Pyramids, and China without the Great Wall. Without the towers, New York is incomplete."

Horror Through Innocent Eyes

PETE HAMILL

That Tuesday morning, we all remembered later, was beautiful. Clear cobalt skies. A brisk September breeze coming off the river. It was Primary Day, with citizens all over the city casting votes to choose their candidates for mayor. In the downtown streets, as I walked down Broadway to a morning meeting, schoolchildren waited for buses or hurried on foot toward classrooms. Some were towed by parents. Others carried knapsacks that seemed like droopy symbols of independence.

Then, at 8:48, came the horror.

For almost two hours, one image followed another, all of them merging, like shuffled cards exploding suddenly in the air. The two airplanes came out of the blue morning, smashing first into the north tower, and soon after into the south. The air broken by sirens and honking horns, the soundtrack of emergency. And there were the other images: great orange fireballs; immense plumes of black smoke; human beings tinier than ants leaping from the floors above the flames of the north tower; firemen rushing into the buildings, never to come out.

Then the south tower made a cracking sound, and the upper floors tilted, and then righted themselves, and then all of it came straight down, making the roaring, screaming sound of an avalanche. Concrete, steel, plaster, wood, desks and chairs, file cabinets and computers, exploded glass, and human bodies—all smashing into each other. One hundred ten floors compacted into ten within a minute, everything pulverized. The earth shook, then settled. The cloud of dust rose, so opaque that it seemed like a solid, rising twenty stories above the point of impact like some escaped and malignant djinn. The horizon vanished, as some of us groped for the familiar world and could not find it. And then there was a silence, partly caused by deafness from the sound of the collapse, partly by astonishment and awe. We emerged into a world white from the dust of the cloud. Trees and tombstones, shops and streets were all white. City Hall was white. Bronze statues were white, and neon signs were white. All of Broadway was white, except for more than a hundred women's shoes, kicked off in flight.

But we were alive while thousands were dead. The second tower came down. The sirens howled. Awe and horror gave way to rage, and all gave way to something else: vulnerability. The mayor uttered his famous words: "The casualties will be more than any of us can bear." And those words allowed another emotion to be expressed, that most human feeling we call sorrow.

Within days, the expression of sorrow flooded the city. There were makeshift altars at firehouses and police stations, candles burning through the stained nights. By that Friday, the city seemed to have become an immense collage. On walls and lampposts, we gazed at the faces of those who were still missing, human beings of all races and nationalities and religions, almost

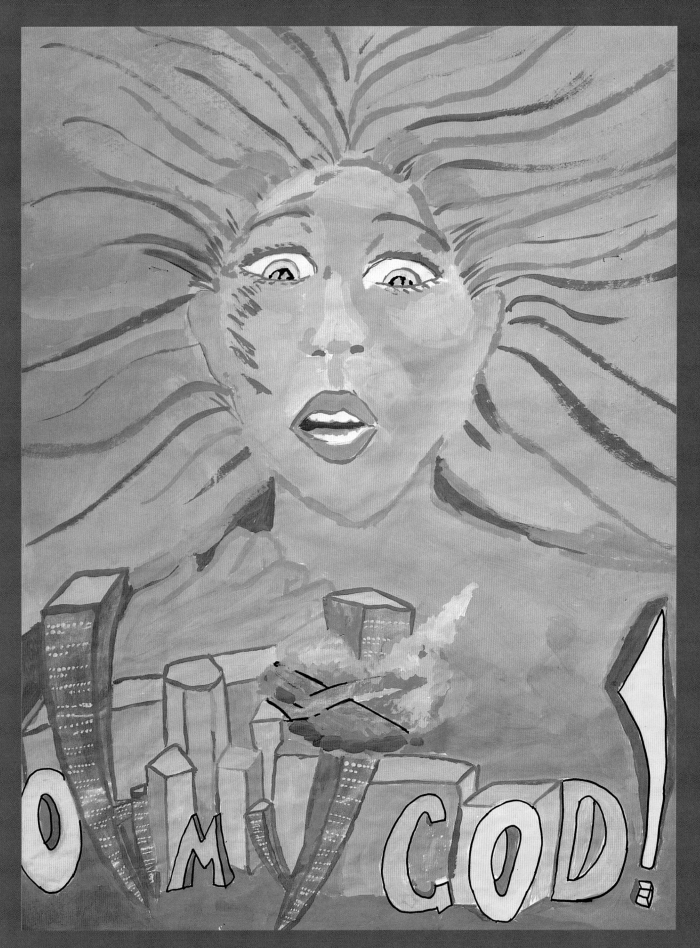

Kitwana Carr, 17 years old. **Untitled.** 23 ¾ x 17 ¾"

all of them smiling because the photos came from weddings or parties. We read the scrawled words of thanks to the firemen and policemen and paramedics who had vanished under the towers. Over and over again, we saw the sentence: "You Ran In When Everyone Else Ran Out."

And then we saw the reactions of the children.

They were drawn with crayons. They were painted in tempera. They were splashed in watercolor. They were pasted together from newspapers and magazines. Some were directed by teachers to help the children make their feelings visible. Other children worked on their own.

And what they brought to the calamity was an innocent eye.

There, in the drawings of the youngest children, were the buildings, two immense towers as flat on paper as Matisse cutouts. And coming at them, black and ominous, were the airplanes.

There in the paintings, displayed on the fences of Union Square and other public plazas, were the images of destruction: toppled towers, great violent explosions of red and orange paint. In some of these paintings, frantic stick figures were screaming. In some, human beings were on fire.

In the works of older children, there were images that combined subtlety with melodrama. There were firemen with heads bent low in mourning, the straps of their suspenders rendered in the exacting draftsmanship of comic books. I saw clenched fists in some drawings and blistered bodies in others. These works grasped for the raw meaning of the calamity, and sometimes cried for revenge. And in many, the flag served as an emblem of the country, sometimes looking injured, more often shown in triumphant full display.

More often, these young New Yorkers conveyed simple human gratitude to those who had sacrificed their lives to save the lives of others. Their paintings and drawings were full of that spirit. If they had learned that the world can be a dangerous place, they had also understood that heroism is not a word emptied of all meaning. Real heroes, made of flesh and blood, actually do live in the world. For some, they lived that morning on the next block. In their art, these young people managed to convey that understanding without the traps of cleverness, free of the guises of slick technique or cheap rhetoric. Nobody can know whether these young artists—and all others who were still innocent that morning—will bear a permanent scar from September 11. It's simply too early to speak of crippling traumas and lifelong uncertainty. They might just as well grow up living with heroic ideals, put there by the brave.

But of this, I'm certain: their pictures will be looked at a hundred years from now with a sense of wonder and awe. One fine morning, horror came out of the clear blue September sky. The New York young saw the horror with their innocent eyes and helped provide us with the consolation of art. ■ ■ ■

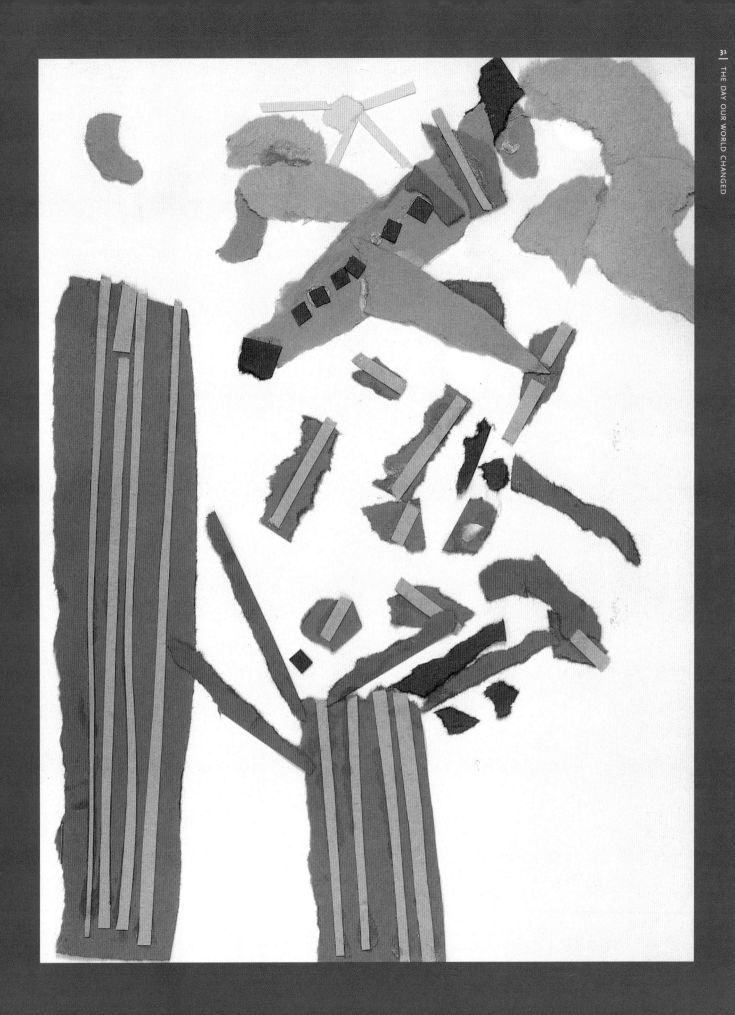

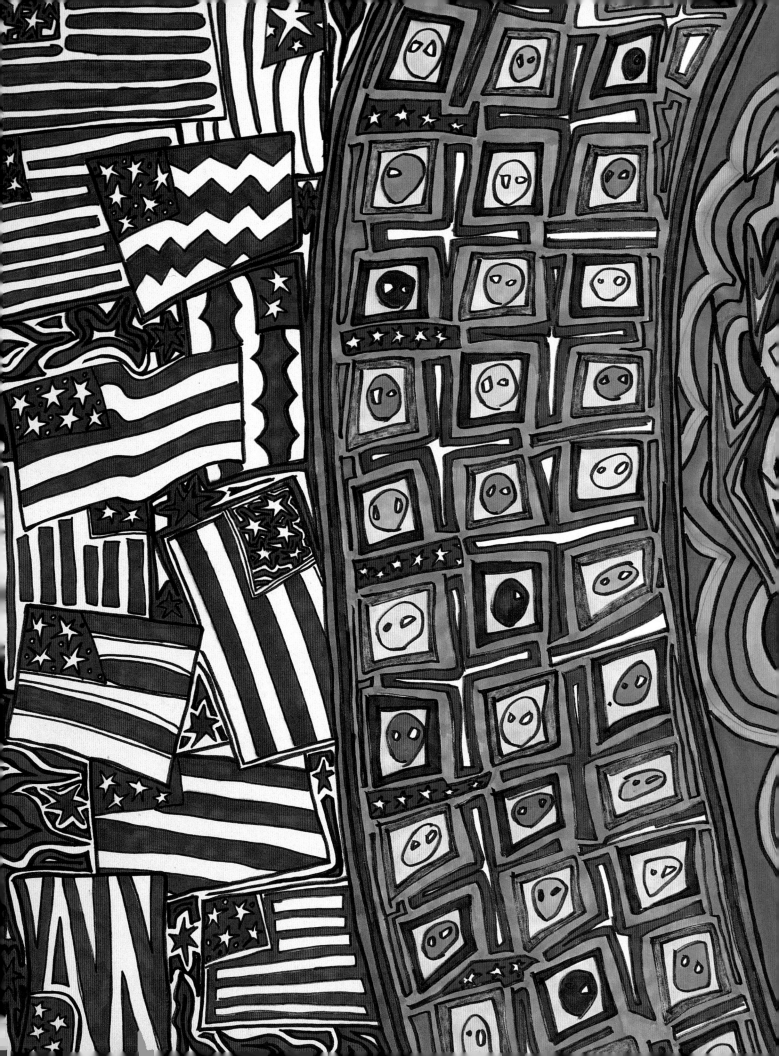

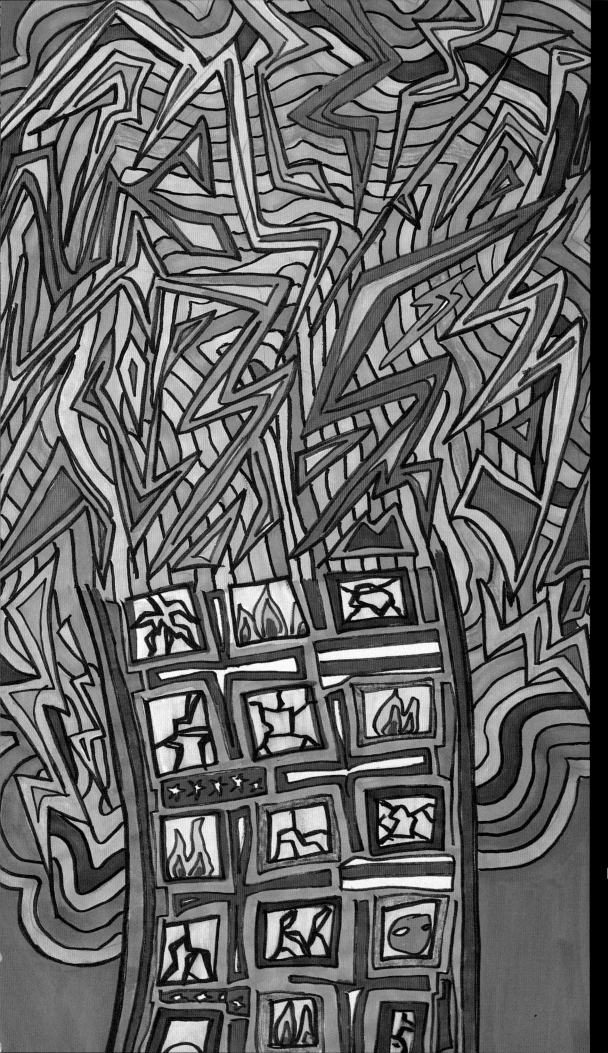

| Claire McTaggart, 17 years old.

Untitled. 18 x 24"

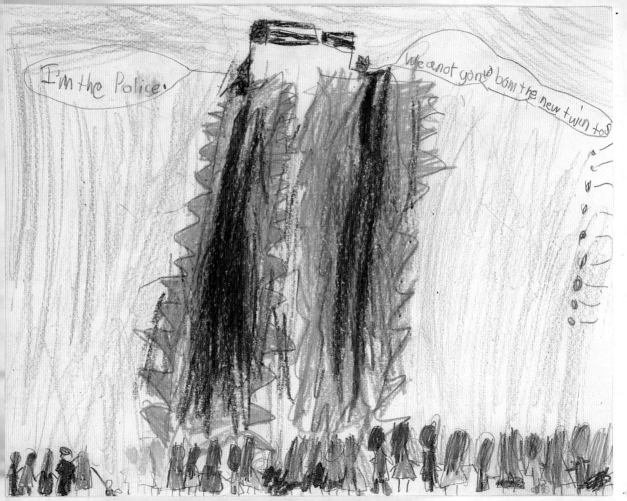

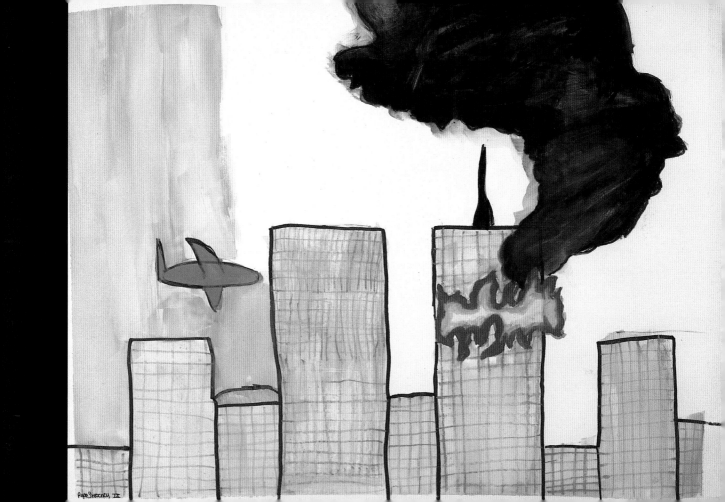

A School In The Towers' Shadow

SENATOR CHARLES E. SCHUMER

As I watched live television coverage of the second plane crashing into the World Trade Center, it hit me that my daughter Jessica was at school within the shadow of those towers. Most of the pictures of the conflagration showed her high school, Stuyvesant, in the background. I called my wife, and for two hours we were in virtual panic, trying to locate her and see how she was. And then, she called. While we were relieved, we knew that those two hours of pure misery would be experienced tenfold, one-hundredfold, one-thousandfold, by all the families who lost loved ones on September 11.

When something this cataclysmic occurs, one's mind works at many, many different levels. The panic I felt that morning was panic as a husband and father, panic as a New Yorker and an American, and panic as a United States senator. Still, my daughter felt these events on a level that I will never fully understand.

We each own a perspective on 9/11 unique from any other—a perspective based on who we are, where we were that morning, and the connections we have to this tragedy. But as we share those perspectives and give voice to the emotions we hold inside, we are united in powerful ways.

I have directed my energies and emotions into working to get New York the money it needs to recover; Jessica and her classmates found great comfort in creating a giant banner for their school. Painted on that blue canvas were reflections of the intense pain, pride, and hope of students who had all started classes that September morning only a few blocks from what became Ground Zero.

We will never forget the images of that day or the emotions we felt—and still feel—in the aftermath, but, as I told Jessica, it is the bonds that hold us together that will lift us back up and carry us forward.

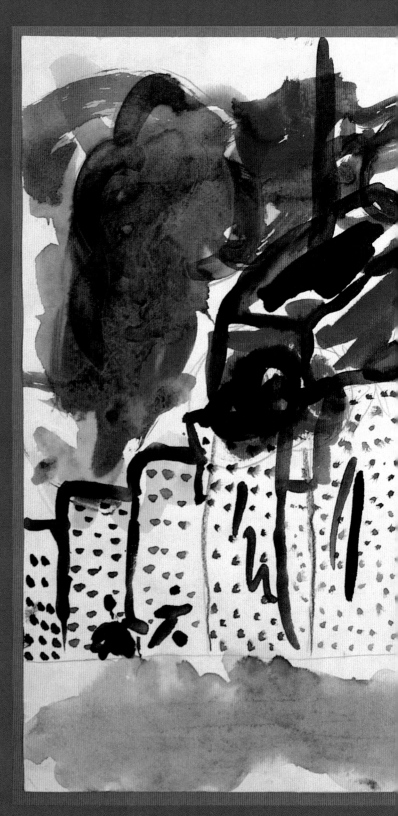

| Nicole Ward, 10 years old. **Untitled.** 12 x 17 $^{15}/_{16}$"

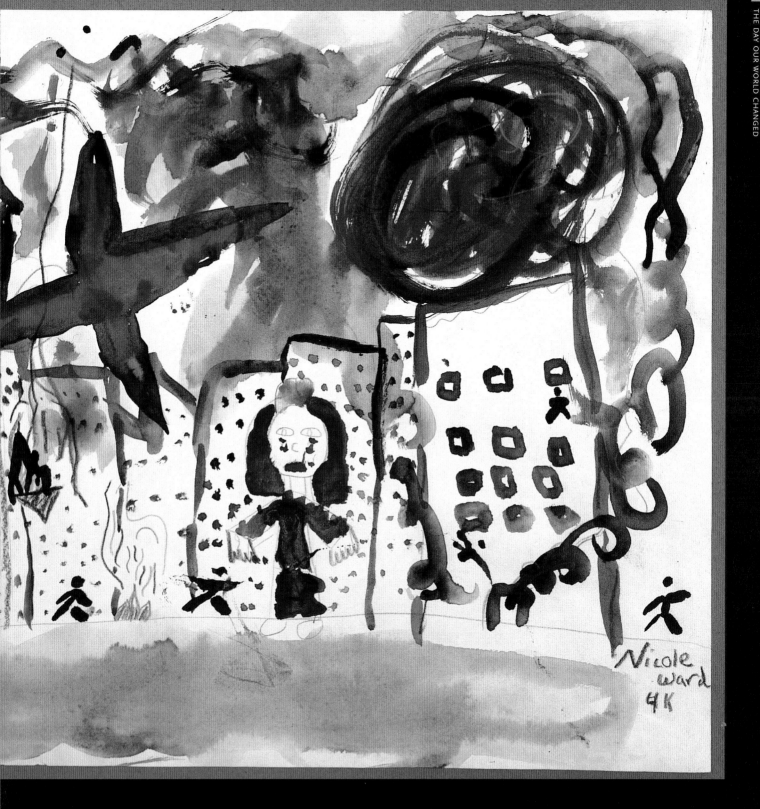

Nicole
ward
4 K

"I saw the planes hit the WTC in the media and I couldn't believe it happened. I saw people jumping out of buildings. My mom had two friends whose wives died. That affected my mom really bad. My teachers and my family comforted us so good it really made me feel better."

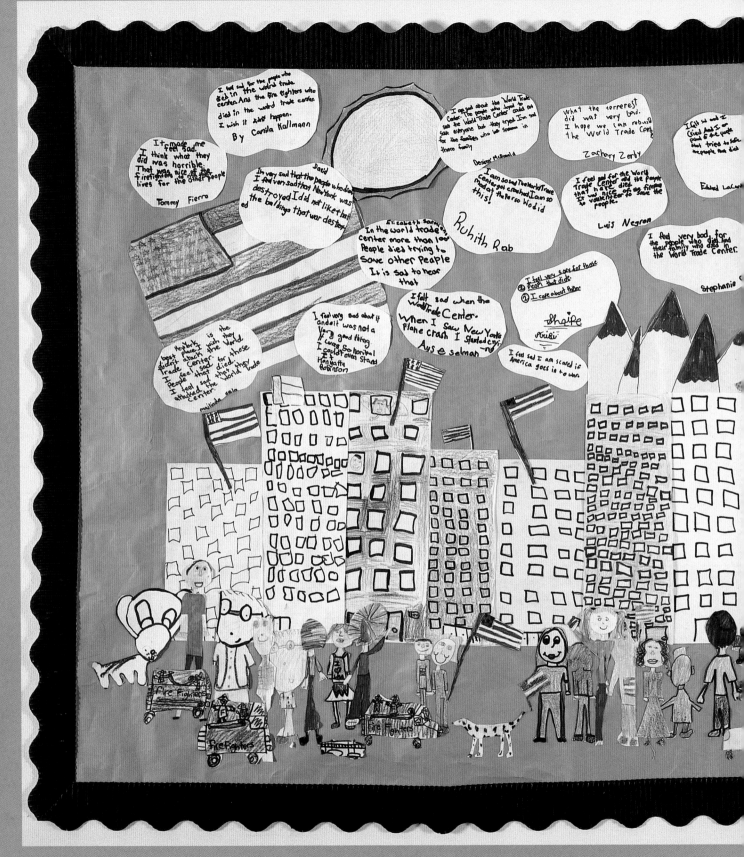

Sitqipe Arifi, 9 years old; Dina Basha, 9 years old; Dylan Boyle, 9 years old; Stephanie Colon, 8 years old; David Espinosa, 9 years old; Tommy Fierro, 8 years old; Besart Islami, 9 years old; Camila Kallmann, 8 years old; Aquil Kohn, 8 years old; Eddie LaCardo, 8 years old; Desiree McDonald, 8 years old; Jose Navarro, 8 years old; Luis Negron, 8 years old; Ruhith Rab, 8 years old; Tatiana Richards, 9 years old; Kenyatta Robinson, 8 years old; Ydiness Santana, 8 years old; Elizabeth Sarmiento, 13 years old; Majlinda Sela, 8 years old; Aijse Selman, 8 years old; Anaika Singh, 8 years old; Zak Zerby, 8 years old; and Anonymous (1). **Untitled.** 38 ³/₄ x 71"

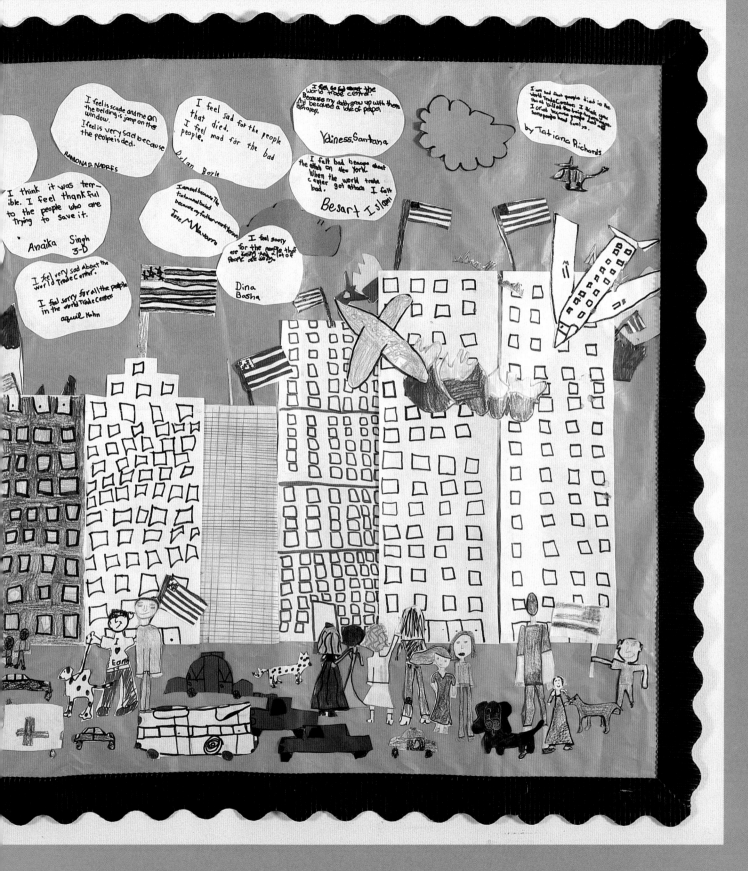

Jackie, 14 years old. **Trying To Find Safety Within Each Other.** 8 ⅞ x 11 ⅞"

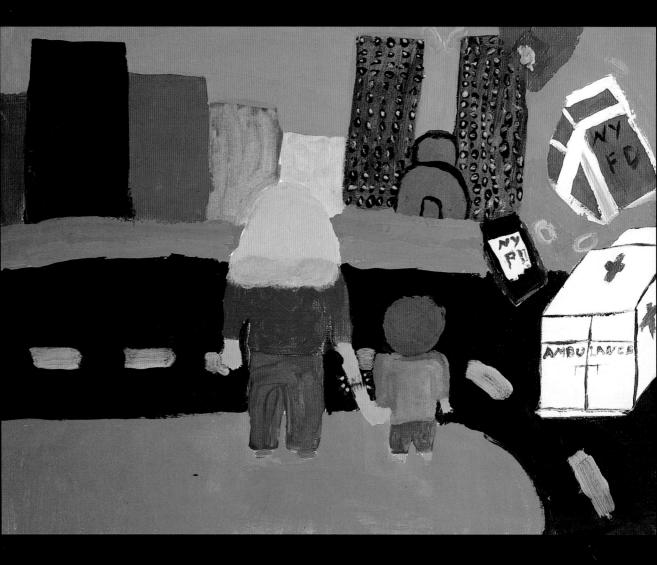

| Pearl Newman, 12 years old. **Disaster 911.** 18 x 13 ⅞"

"It was a very sad day for America."

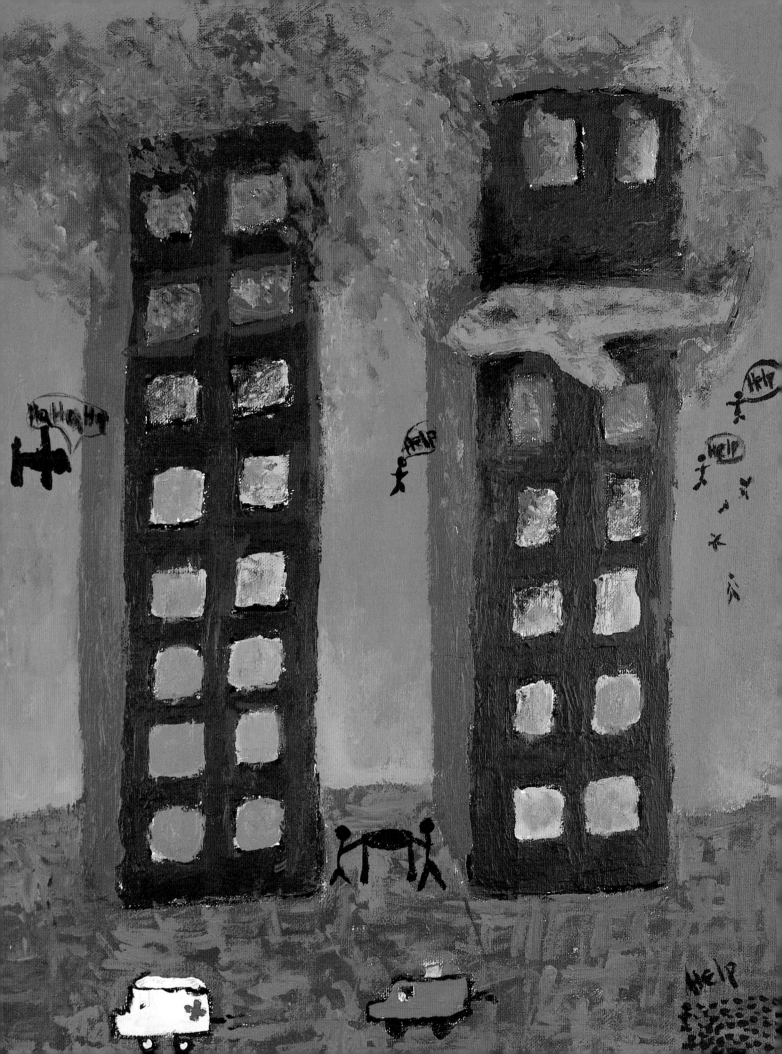

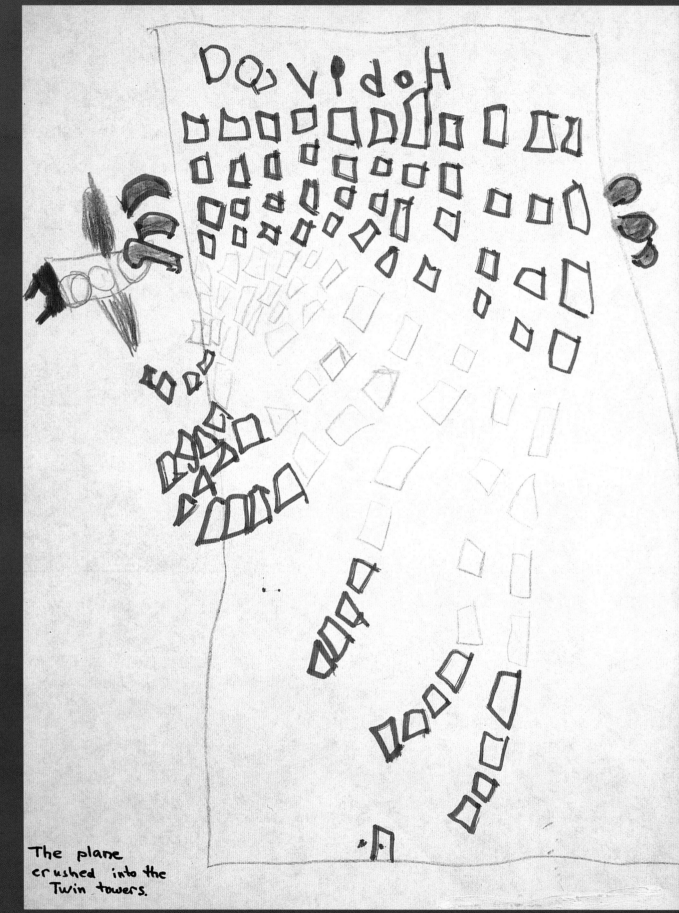

The plane crushed into the Twin towers.

David Heifitz, 5 years old. **Untitled.** 11 x 8 ½"

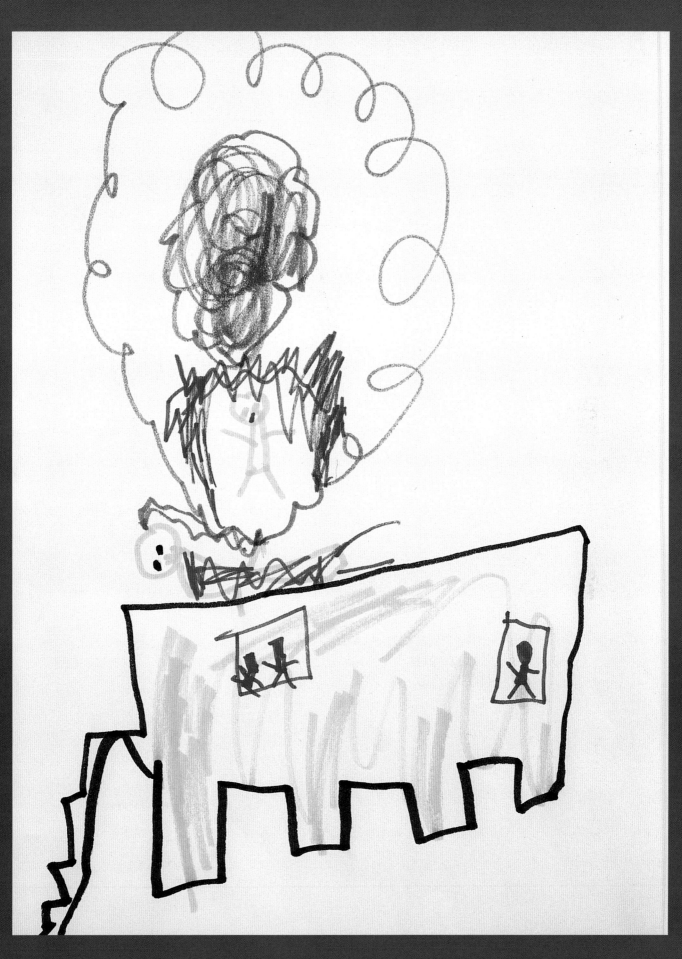

| Quinn Taylor Kelley, 6 years old. **In Bed Dreaming.** 12 x 8 ¼"

"This is me in bed dreaming my mother is in smoke and fire."

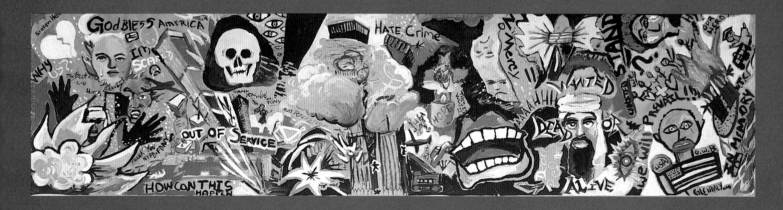

| Julissa Abreu, 16 years old; Ousmane Barry, 17 years old; Yohanni Caba, 18 years old; Lashay Carr, 17 years old; Matthew Chow, 16 years old; Helen Chu, 17 years old; Glendaly Davila, 17 years old; Elisa Espinal, 16 years old; Camille Fletcher, 16 years old; Francisco Frias, 18 years old; Latoya Ifill, 16 years old; Karolina Jakubowska, 17 years old; Tiffany Kirkland, 16 years old; Beth Martinez, 16 years old; Anna Murawska, 16 years old; Nachelle Reyes, 17 years old; David Simon, 17 years old; and Gerardo Taveras, 17 years old.

Untitled. 35 ¾ x 147 ¾"

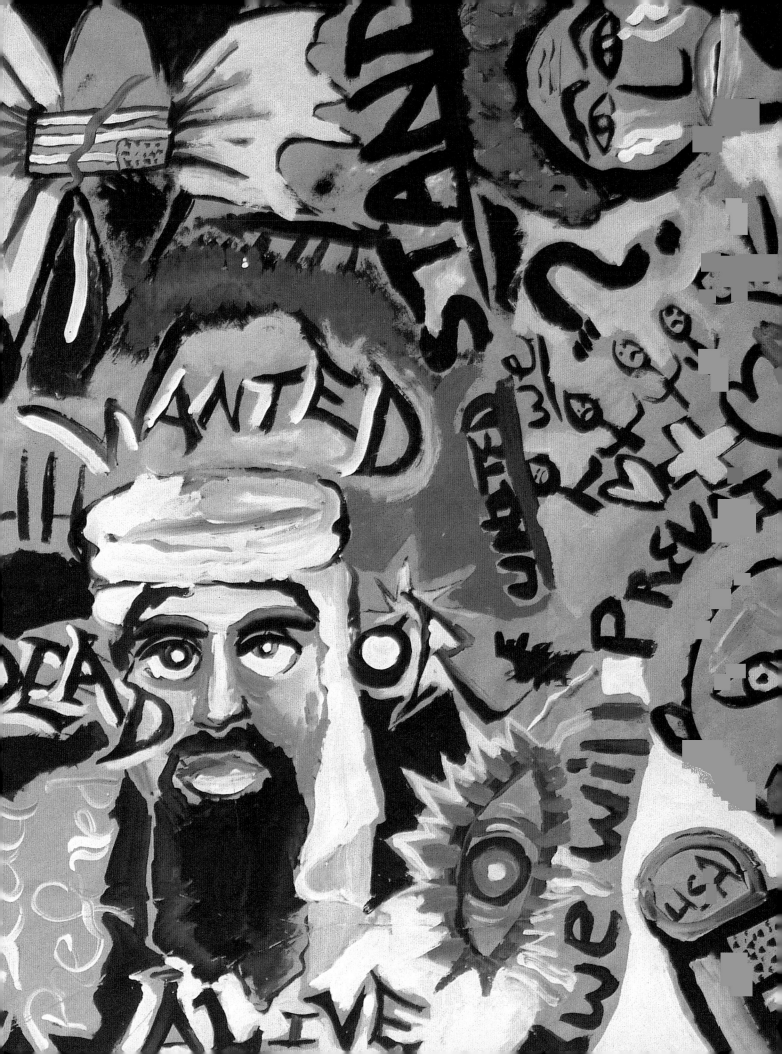

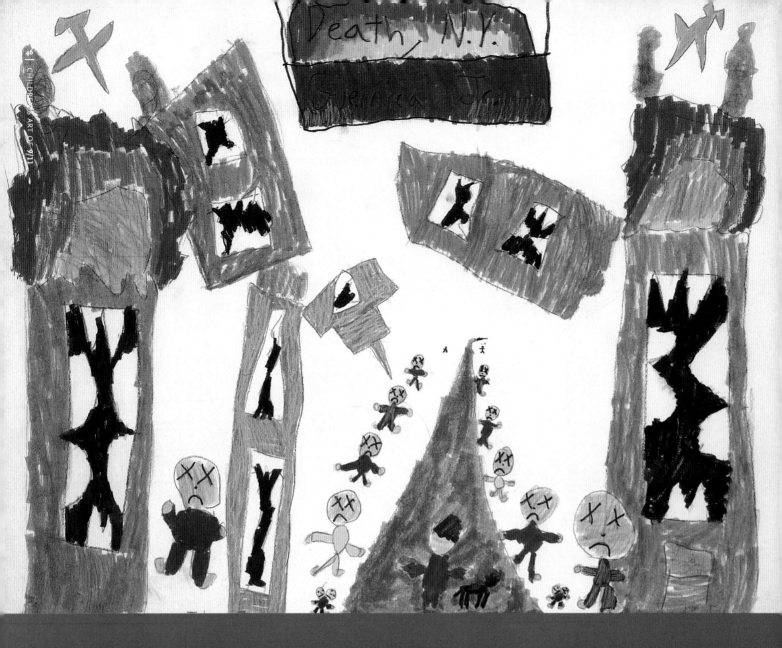

| Joshua, 9 years old. **Children's Guernica.** 18 x 24"

"The Children's Guernica's relation to Picasso's Guernica
 is that I wanted to show how disgusting war is."

| Anthony McKane, 13 years old. **In Rage.** 20 ⅞ x 20 ⅜"

"In my self-portrait, I showed my feelings about the attack on the World Trade Center. I am in rage and feel like a victim. I want the people involved to pay for their crimes."

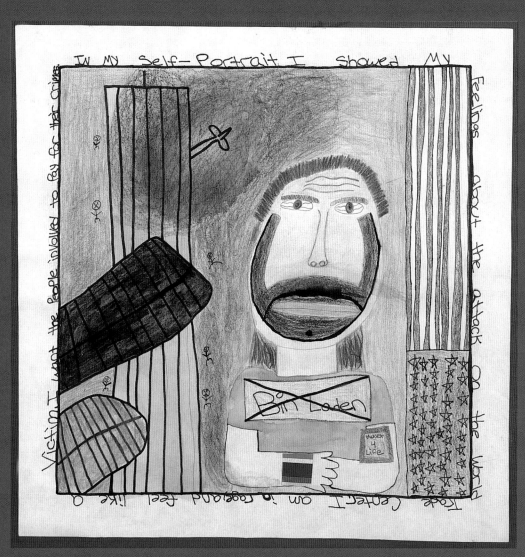

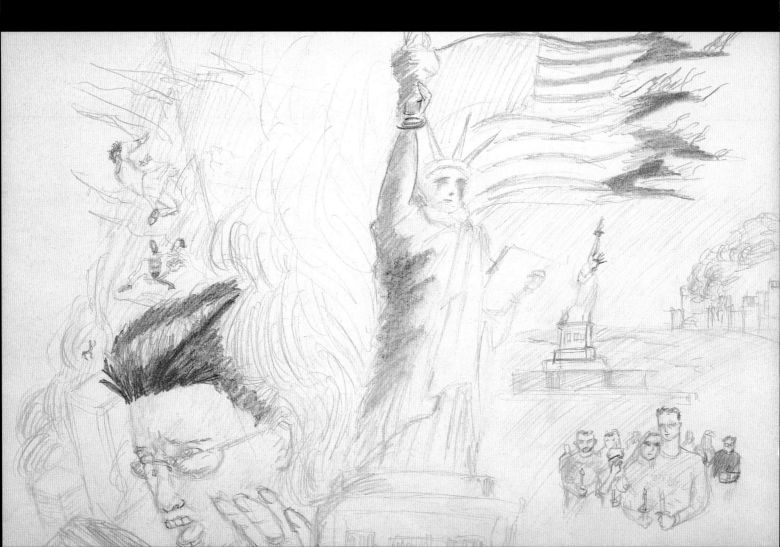

| Matthew Tuffy, 11 years old. **Inside View of a Chunk of History.** 12 x 18"

"I felt sad about people who died or lost family members. I imagined that before the second building fell over they were really terrified of what was happening. The future looks not really good with what's been happening. People that are involved with this should think about it."

Our Art Is the Enemy of Death

TIM ROLLINS

It is September 11, Primary Day in New York City. I am walking down Prospect Avenue in my South Bronx neighborhood toward the local voting place. I'm rushing. I need to get downtown to our Manhattan studio to work with several members of our art-making team, K.O.S. (Kids of Survival). An exhibition of our new collaborative paintings is due to open in eleven days in New York. We are finishing a large-scale work inspired by Shakespeare's bloody tale of *Macbeth*.

My cell phone is ringing. It is Rick, who has worked with K.O.S. for seventeen years, since he was thirteen years old.

"Tim, I've been trying to reach you for an hour! Are you all right?"

I'm a little irritated because I can tell Rick's not in the studio, and I'm feeling deadline pressure for the exhibition. "Where are you, Rick?"

Rick is raising his voice. He sounds panicked. "Tim, don't you realize what's going on? Terrorists have flown huge airplanes into the World Trade Center, and the towers are totally destroyed. The World Trade Center is gone, and we're at war!"

I'm disbelieving.

"Tim, it's true. All the subways are closed; you can't get downtown." Rick knows me. "Don't go downtown. Please, go home!"

I've lost my signal. I race back to my apartment a few blocks away. I get to my place, turn on the TV, and it hits me at once. I'm crying. Everything— everything—has changed.

I phone my mom in the rural hills of central Maine. No signal. I try again. Again no signal. One more attempt, and I get through.

"Mum, I'm all right. I was here uptown when it happened."

Mum, a Mainer through and through, sounds angry. "You were bored here in the country, and you moved to New York City to get some excitement. Well, you sure got it now!"

I can tell that she's worried about me. She's furious that her oldest son's great city, her nation, and her world have been brutally attacked. I assure her that I'm all right and promise to keep her posted through the day. She knows me. "Stay home, Timmy."

I'm off to the subway station. The token booth attendant tells me the train about to enter the station will be the last one heading south, and it is only going as far as Grand Central Station. I take it, though I will have a twenty-block walk

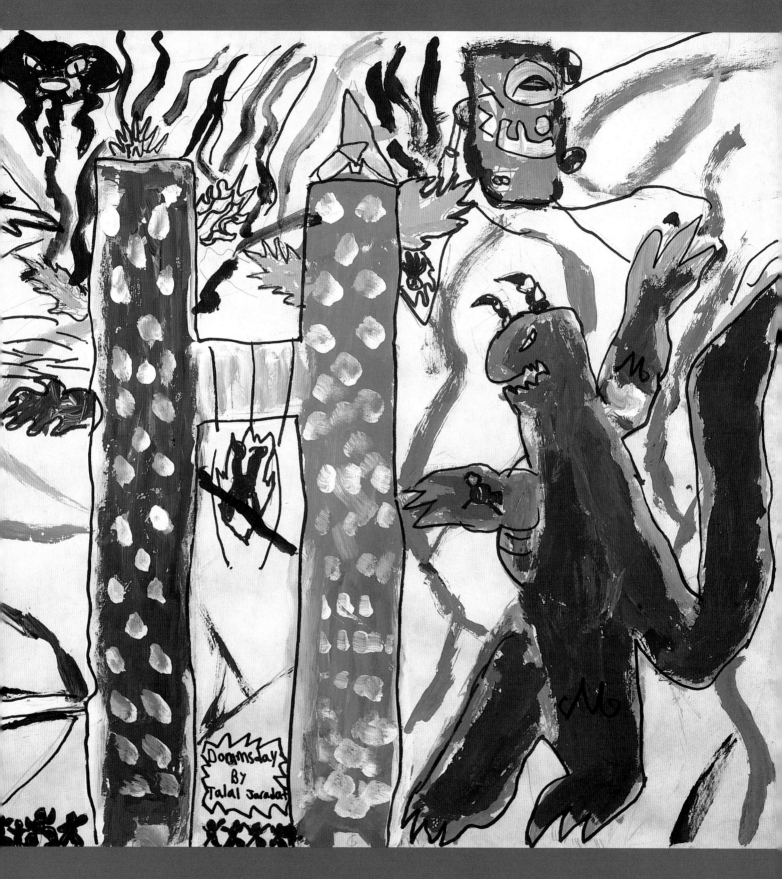

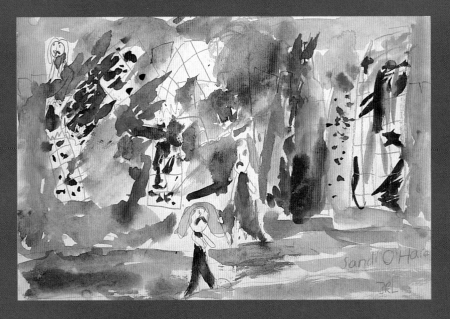

| Sandra O'Hare, 8 years old. **An Unhappy Day in N.Y. City.** 12 x 17 ¹⁵⁄₁₆"

when I get there. I'm going downtown. I want to get to our studio in Chelsea, approximately two miles from where the Twin Towers were. I want to be a witness to all this. The train moves very slowly downtown. The passengers' faces are all expressionless.

I get off at Grand Central, and once out of the terminal, it hits me. The smell, that smell. I know it from somewhere before. Was it the odor of the burning garbage dump that I recall from my childhood in Maine? Close, but no. How do I remember that smell?

I'm walking toward our small studio. Everything and everyone is silent with the exception of the constant sound of sirens.

High above West Twenty-sixth Street, the studio windows face the southern tip of Manhattan. Brilliant, direct sunlight streams in through the large windows. I look straight ahead of me. To my right is a glistening, glittering Hudson River. To my left, in the place where two tall old friends once stood, is a single poltergeist the color of zinc white pigment. I turn around and look over to the tables where we have been working on the bloody *Macbeth* piece. The horror of the art now seems symbolic, premonitory. I look out the windows again. The horror of what has happened is concrete and thoroughly final. In the studio,

creation. Down the streets, destruction.

It's now the morning after, and I'm back in the studio. The window facing south is open, and the ghostly smoke has stretched farther upward. The smell is even worse. Now I recognize it. That smell, that odor of dying and desolation—sour and tenacious, sticking in the nostrils—was the first sensation I experienced the day I began my new job teaching special-education students in 1981, when the South Bronx was forever burned and burning. Things had changed in the Bronx. That seemed long ago, banished forever. Now here it was, times ten.

Back in those days, when the Bronx was on fire, there was much concern about how children living in this impossible environment could survive psychologically. Some educators adopted the "whistling in the dark" strategy. The hallways of their deteriorating schools were permanently festooned with brightly colored nature scenes concocted out of construction paper, in direct contrast with the world outside the barred windows. Denial was the tack taken by other school officials. They insisted that outsiders grossly exaggerated the drugs, violence, arson, and abandoned buildings of the South Bronx. As a new and struggling art teacher of junior-high special-education kids—kids with a laundry list of learning, emotional, and social

problems—I was immediately impressed by how my kids' love for art survived in spite of their struggles in school. When left to their own devices in the art room, the pain and frustrations of their daily situations, the events they witnessed, their anger and even joy were manifested in pencil, crayon, and marker on sheets of cheap drawing paper. They drew fire, fire, fire everywhere, and images of monsters and demons abounded. So did dozens of new superheroes, created by the kids in hope of salvation. I was always amazed at the fearless truth of the imagery. They used their art to testify about their lives and to negotiate tragedy. This direct dialogue with the world through art-making gave my students power to assess and determine their place in the world. It gave me hope then and still does.

For more than two decades, I have made art with children from the most troubled communities: first in the most distressed parts of New York City in the 1980s, then with the teenage survivors of the Oklahoma City bombing in the '90s, and most recently with the kids in the battlefield that Israel has

become. My students and I have seen and known destruction, and we have participated in healing and reawakening through art, following in the path of the pioneering work of Dr. Robert Coles' "Children in Crisis" series. This kind of artwork is a means to wrestle with the sadness of September 11. The unique collection of children's art gathered here is once again evidence of young people's innate and uncanny capacity to discern, observe, and make visible our inevitable confrontation with evil. The works are living testimonies to the power of art to save histories, minds, and lives.

When children draw, a new world is invented, with emotions that were once invisible and unexpressed. Kids' ideas and perceptions of reality, their feelings, and their experiences are translated into imagery, and this translation results in a strange, strange beauty. In its essence, art is not only an act of representation. Art, especially the art of children, is an act of hope that beauty can and will change things. Art, especially the art of children, is the enemy of death.

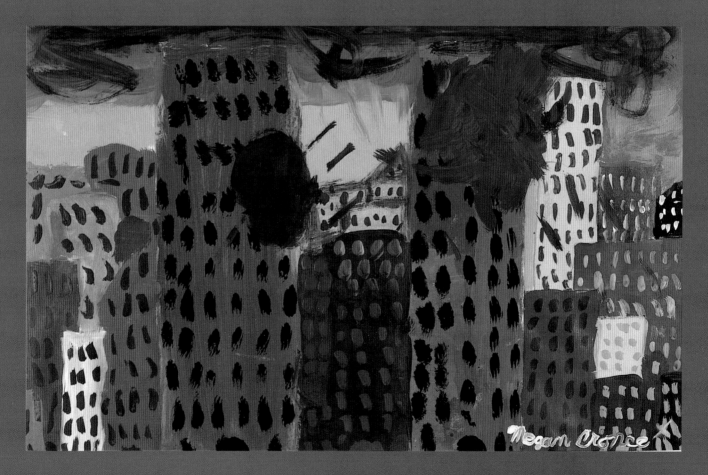

Megan T. Cronce, 11 years old. **Untitled.** 11 3/16 x 17 1/4"

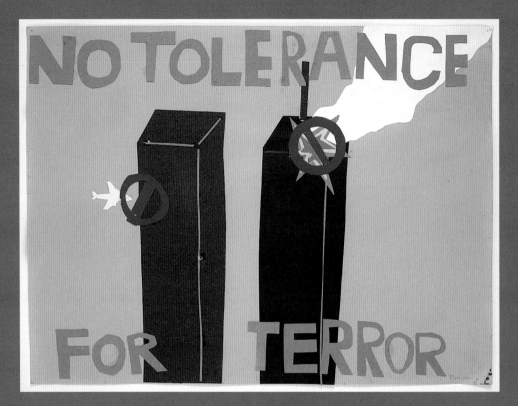

| Brian Lehrer, 13 years old. **No Tolerance for Terror.** 17 ⅞ x 24"

| Annie Mak, 17 years old. **Osama's Toys.** 23 ⅞ x 17 ¾"

"The painting of Osama eating the Twin Towers would be helpful to understand the anger put over America and symbolism."

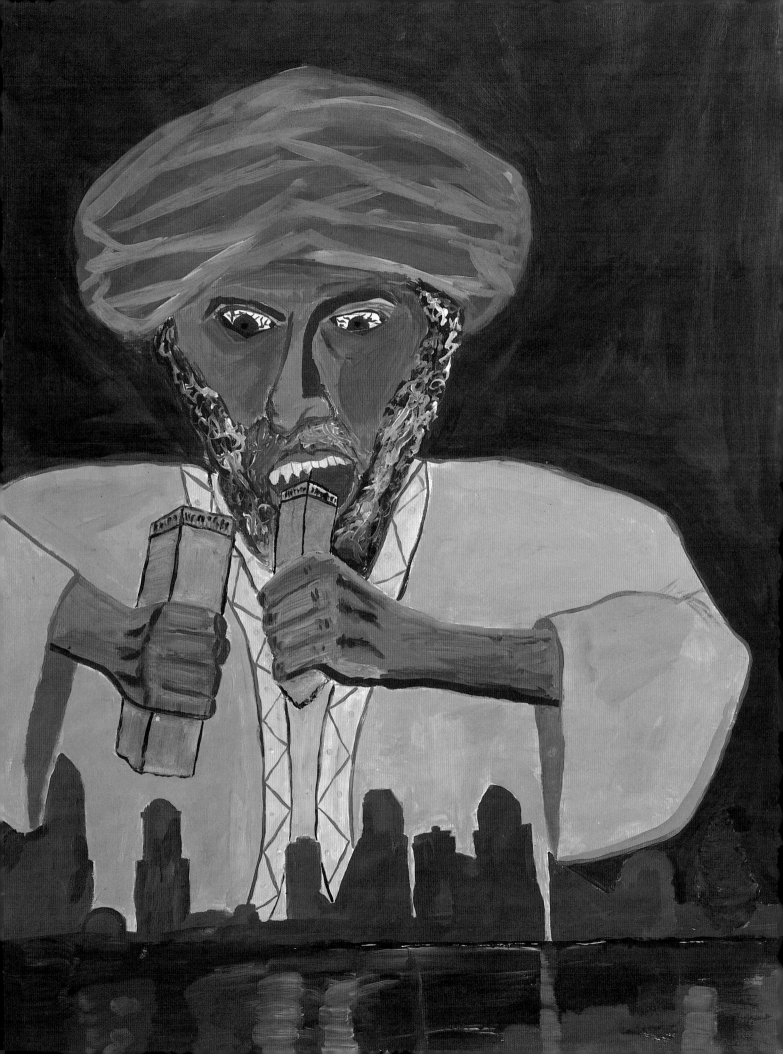

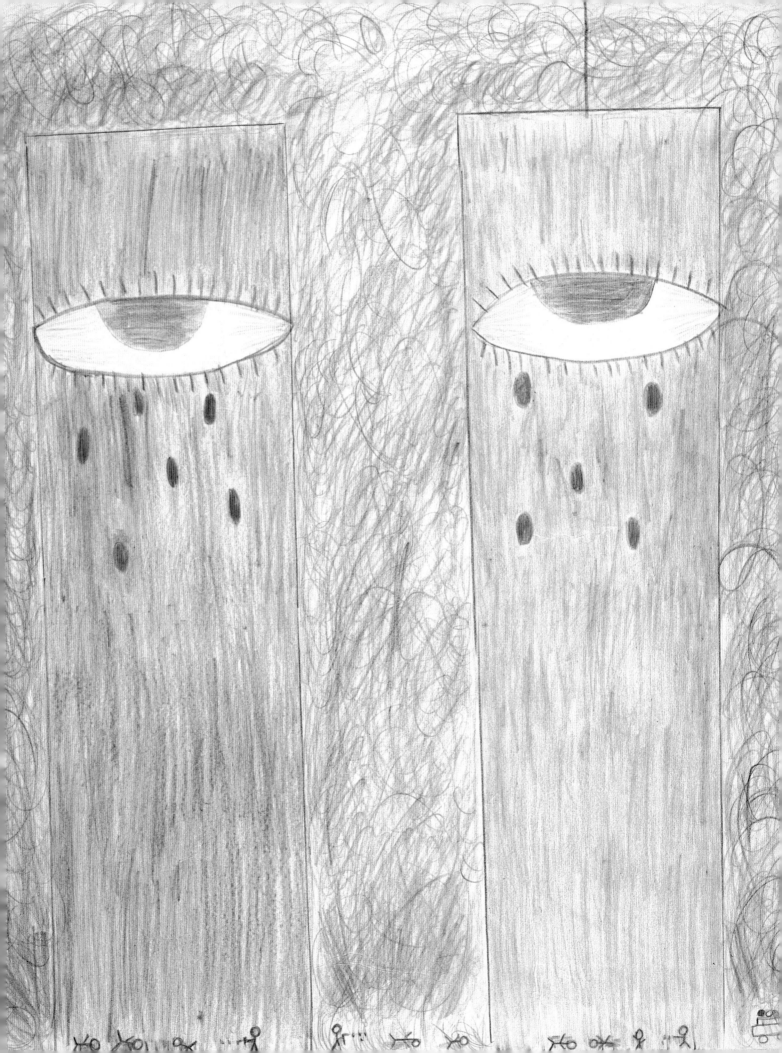

THE CITY MOURNS

| Tamara Obradovic, 9 years old. **America Is Crying.** 19 ⅝ x 22 ⅞"

The Sunday After 9/11

REVEREND ALAN GIBSON

Five days after the attack, our suburban church gathered for its usual children's service. It came as a relief for us all to be in church together just like every other week. We needed the familiar ritual of worshipping God together. Before the weekly Bible story, I asked the children if anything was bothering them. The very small ones did not realize that this Sunday was different from any other. How blessed they were, I thought. But the older ones knew that something was very wrong in their world.

Some children could only think of the dramatic television images of the planes crashing into the towers and people jumping from upper floors. But these images seemed more like a video game to them. After all, it was television. Others couldn't get over a particular heartbreak, such as the firedog whose body was found in the wreckage. For the older ones, the story had become personal. They saw the tragedy affecting real human beings, like their mothers who could not stop crying or friends whose fathers were missing. Each child old enough to be aware of these horrible events focused on one thing. That is how they understood the tragedy, through a single sadness.

After a while, the children grew quiet, and I read them the story of Lazarus, Jesus' special friend who died. The Bible says simply, "Jesus wept." The children now understood, as one child put it, that "God gets sad when people get hurt." Then I asked the children, "Do you know anyone who is feeling hurt right now?" Their little heads nodded. "Are any of you feeling sad?" More nods. "Why don't we tell God about the sadness and the hurt. How could we do that?" "We can pray," one little girl suggested. So quietly, these children told God about feelings that are larger than anything any adult could comprehend. As they were praying so earnestly, I remembered Jesus' words: "Let the little children come to me; do not stop them; for it is to such as these that the kingdom of God belongs" (Mark 10:14 NRSV). ■ ■■■

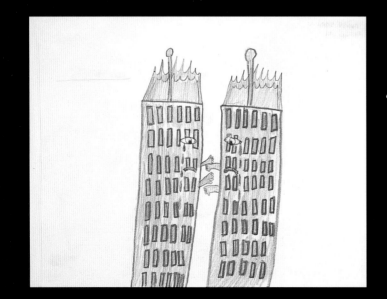

| Andrew, 12 years old. **Having Each Other.** 8 ½ x 11"

"At least the Twin Towers have each other and could say their last words. I would hope I could tell anyone I knew how much I cared."

| Kimberly Babinecz, 13 years old. **Untitled.** 18 x 12"

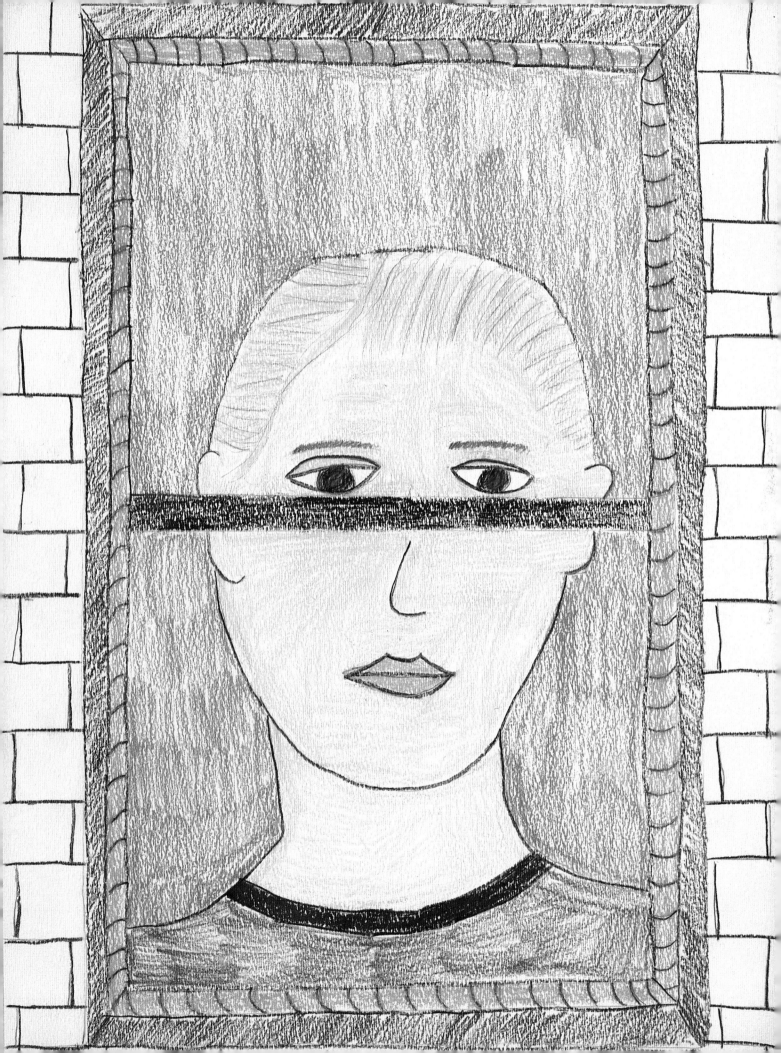

"I remember going home that night of the Twin Tower bombing and watching the same footage over and over again. I felt so sad just watching, knowing I was a bystander but at the same time I was kind of relieved that I wasn't one of the many victims. Tears welled up just thinking about the thousands of people who lost their lives helping out or just being at their jobs!"

| Ella Lyons, 14 years old. **The Day the World Changed.** 20 7/8 x 21 3/8"

| Alisia Orozco, 13 years old. **Shock.** 18 ½ x 19"

"My portrait shows me when I was shocked. I was shocked because the Twin Towers had fallen. I did not believe it was happening."

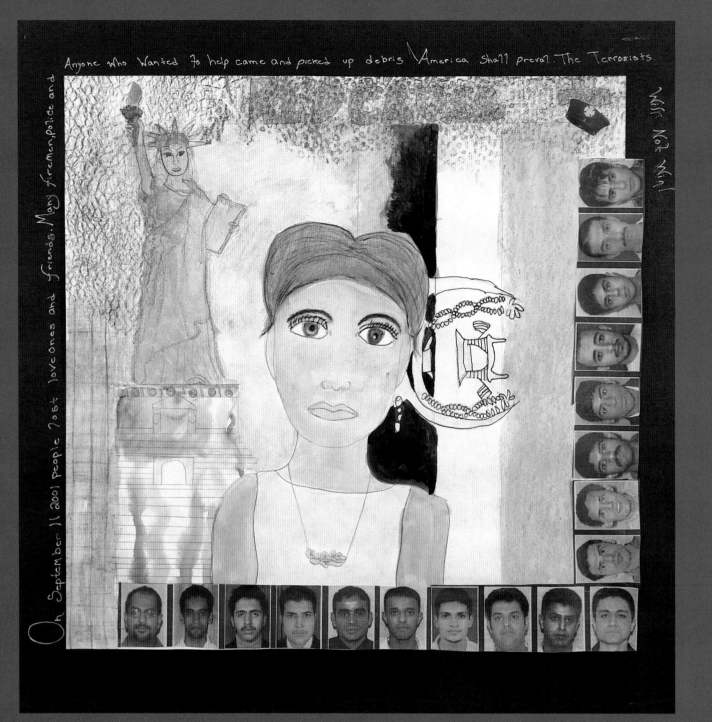

On September 11 2001 people lost loved ones and friends. Many firemen, police and

Anyone who wanted to help came and picked up debris. America shall prevail. The Terrorists

Will Not Win!

| Carla Aumick, 13 years old. **Between Two Worlds.** 22 x 21 ⅞"

"On September 11, 2001, people lost loved ones and friends. Many firemen, police and anyone who wanted to help came and picked up debris. America shall prevail. The terrorists will not win."

"My picture shows the WTC attack on 9/11/01. It shows the
first building on fire and the second about to get hit."

| Alex Marroquin, 13 years old. **How I Felt on September 11th.** 20 ⅜ x 19 ⅞"

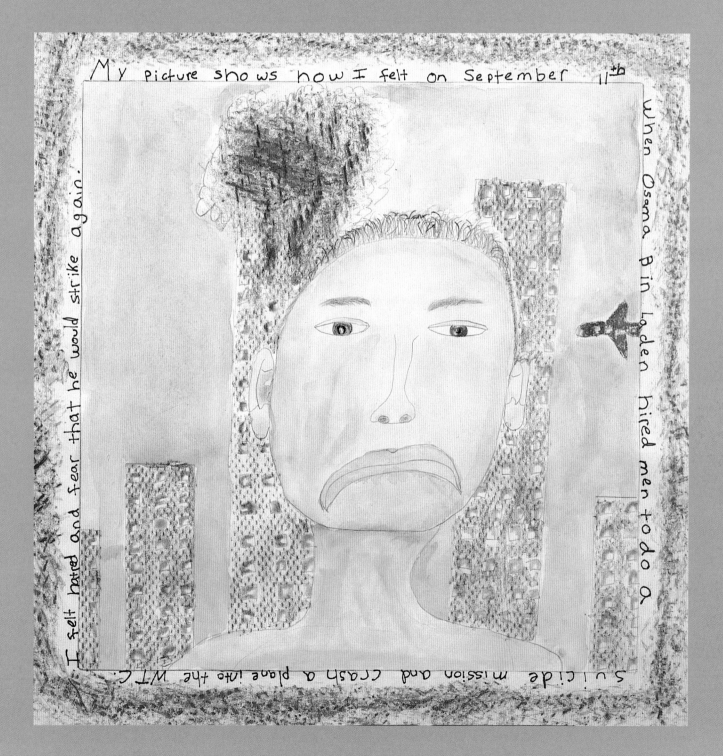

| OVERLEAF: Manuel Rodriguez, 12 years old. **Pain in New York.** 12 x 17 ⅞"

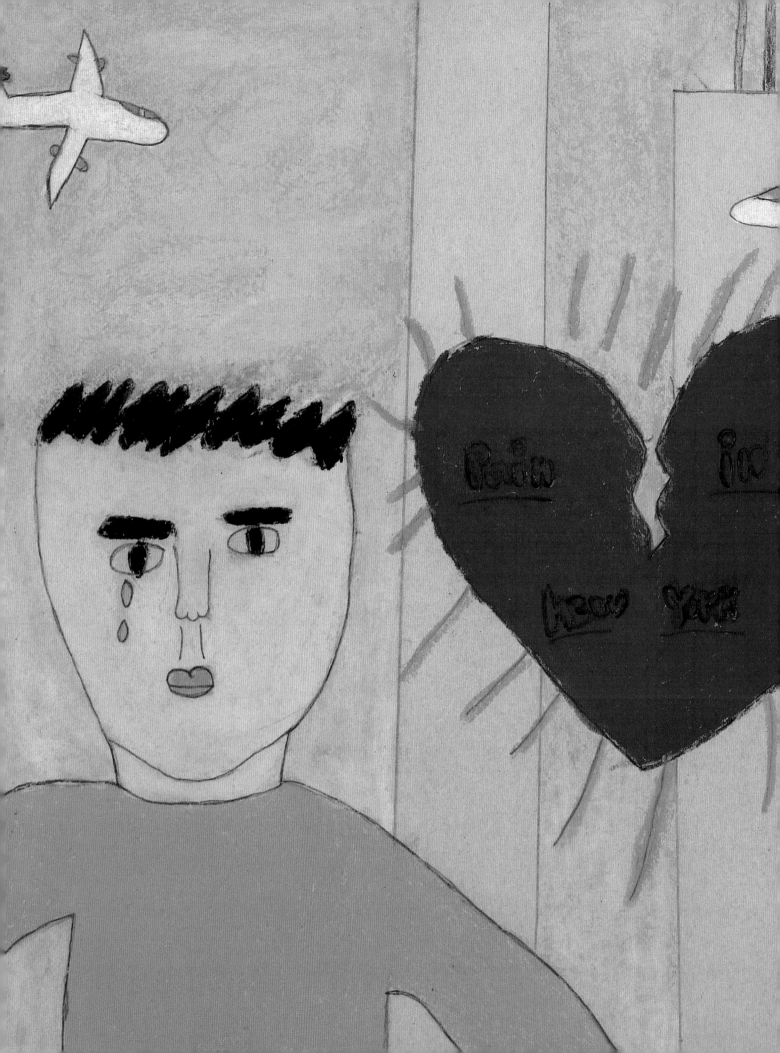

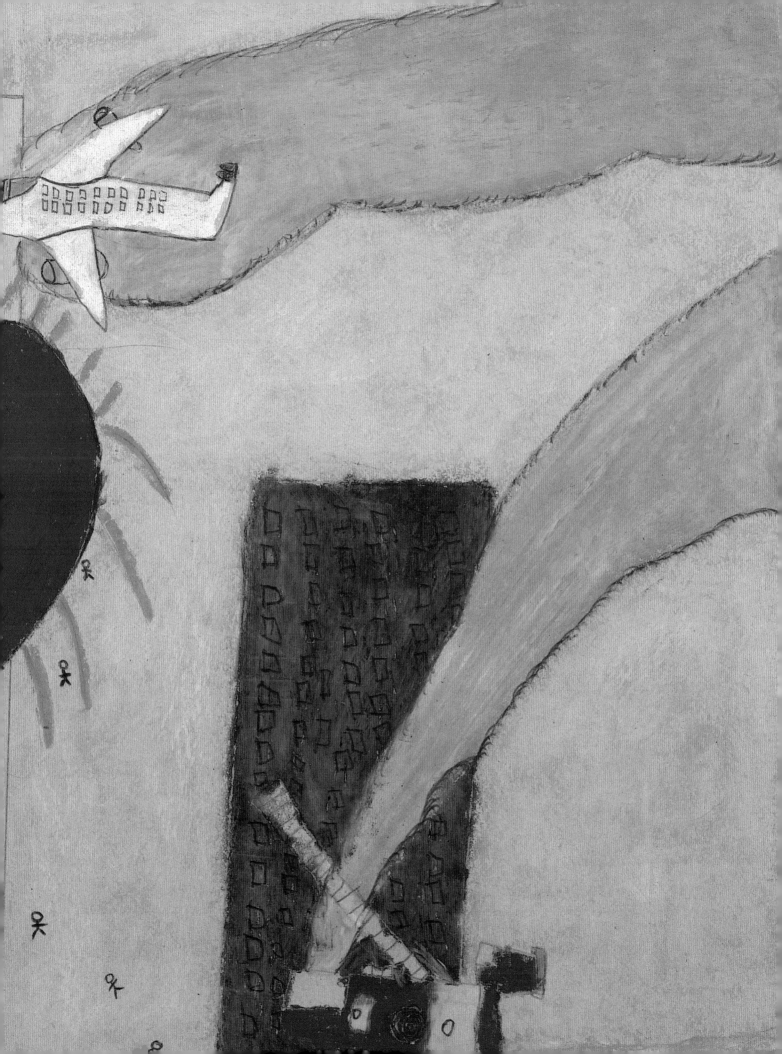

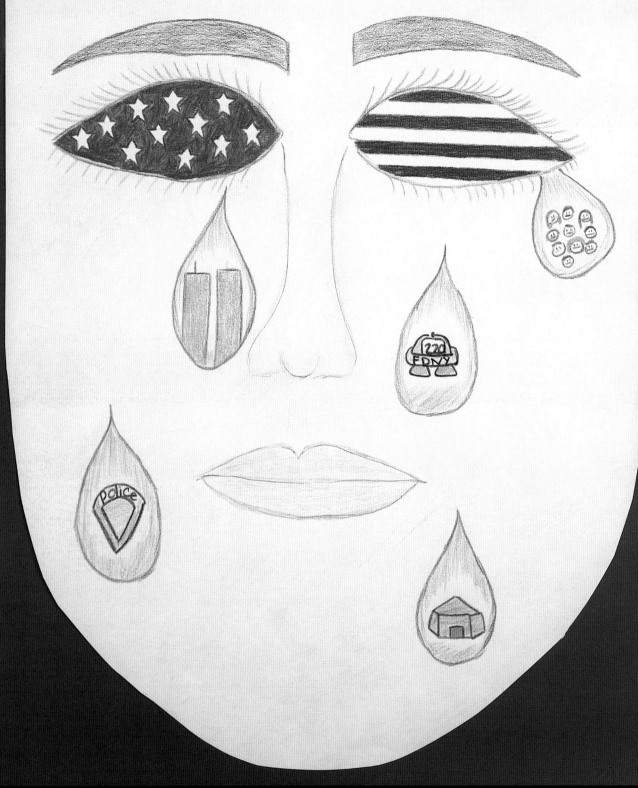

| Meghan Hall Plunkett, 16 years old. **Tears of A Nation.** 14 ½ x 11 ½"

"I am more than honored to say my firefighter father was a true
hero that day and more than glad he's still here with me."

"I watched my mom reading the paper, and even though she was not born in the U.S., she became intensely patriotic and saddened. I decided to show the actual paper she was reading to explain what she was feeling through primary sources."

| Paula Brady, 17 years old. **American Reading the Paper.** 24 x 18"

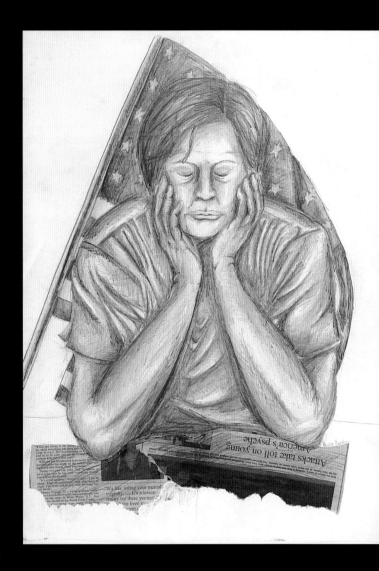

Growing Up Arab-American

DEBBIE ALMONTASER

The night of September 11, 2001, I sat in my study watching the day's disasters on television. As an Arab-American, a teacher, and a mother, I felt a tremendous sense of responsibility to those I cared about. It was only the third day of school at P.S. 261 in Brooklyn, and my new students barely knew me. All I could think about was, How will the children and their families perceive me? Will they come to know me as a caring, loving human being? For my own children, I wondered how their lives and identities as American-born Muslims would be changed.

Earlier in the day, many at school and elsewhere had assumed that the perpetrators had been Arabs. I told my students that I was an Arab-American, and that it hurt my feelings to hear people jump to conclusions and make ethnic slurs. My students felt bad after I revealed my ethnicity. It was an opportunity that no teacher could let pass by. This led us to a conversation that helped them to understand that we shouldn't blame all people of a particular race or religion, and we should use words carefully. When I gave them examples such as "All kids are lazy" and "All Spanish people eat only rice and beans," they started to understand what I meant.

Besides blame and speculation, the students' immediate concerns needed attention. The children asked: Is our school safe? Will this happen again in a few hours? Is our country under attack? What is the government going to do about this? These were questions for which I had no answers, but God gave me the wisdom and energy to handle them in a way that made my students feel safe. Toward the end of the conversation, one student asked if I was scared. I asked him why he asked. His response was, "I would be scared if I was Arabic because everyone would be angry with me for what happened, if those who did it are Arab. I am scared for you." I wondered if his kind feelings would continue after the media began the nonstop coverage that was sure to follow. I was touched by the boy's concern and asked

him what I should do. His response was: "Don't go home alone."

Ten- and eleven-year-old children knew exactly what I was going to face as an Arab-American woman wearing a hijab (head cover). Muslim women cover their hair to fulfill their Islamic duty to God, who asked men and women to dress modestly and lower their gaze. Wearing a hijab is a way of showing our devotion, the way nuns show their devotion to the church in part through their dress.

On September 13, when classes resumed, my fears of not being liked or respected by my students dissolved when they ran to hug me in the schoolyard. They were relieved to see that I had come to work despite the backlash that had already begun against Arab-Americans. Parents also greeted me with warm smiles, appreciative of my dedication at a time of such fear and uncertainty. A group of parents offered to escort the Arab and Muslim children to school for as long as necessary. Encouraged by this, I was able to venture out into my Brooklyn community to reassure parents of different ethnic and religious backgrounds that they needed to send their children back to school, that they should not worry about their safety there. Not all the parents were convinced, and some kept their children out of school for days, even weeks.

It was one thing for me to feel safe at school and close to home; the city streets and train platforms were another story. After September 11, Arab-American and Muslim women, in particular, became very limited in their daily routines. I, for one, was afraid to go out alone in public because of my hijab. For a muhajaba (veiled woman), life had become a daily jihad. Jihad means struggle, and after September 11, the looks and stares I got made me wish I could disappear. I wondered if people saw me as an extremist Muslim—a terrorist—or perhaps as a poster girl for the oppressed women of Afghanistan. My husband became my escort; he drove me to work and drove me home, and I went nowhere else. We were afraid of the kind of verbal and

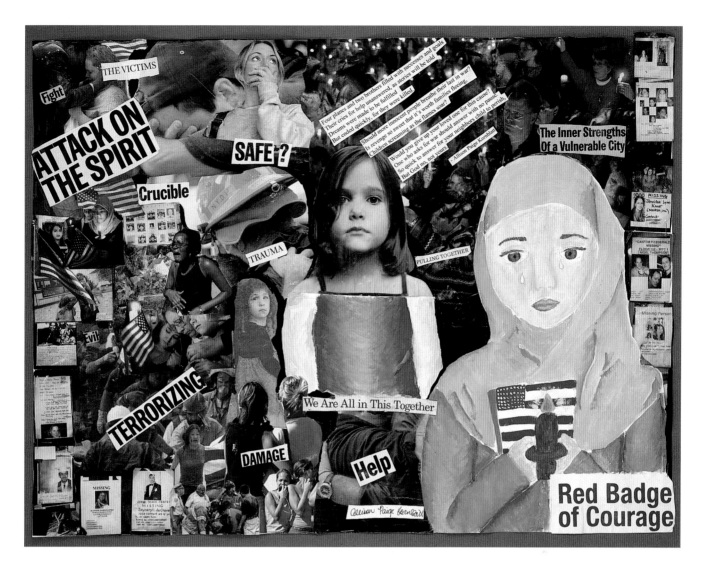

THE VICTIMS

Fight

ATTACK ON THE SPIRIT

SAFE ?

Crucible

TRAUMA

Evil

TERRORIZING

DAMAGE

Help

We Are All in This Together

PULLING TOGETHER

The Inner Strengths Of a Vulnerable City

Red Badge of Courage

| Allison Paige Kornblatt, 13 years old. **Your Neighbor's Child.** 18 x 24"

physical attacks other Muslim women were experiencing.

All this reminded me of my youth in Buffalo, New York. When I was three years old, my family moved from Yemen to Buffalo. As a child, I faced great difficulty finding my identity as an Arab-American Muslim. I grew up at a time when it was very hard to practice Muslim traditions in America. I had long worried about wearing a hijab, but one day when I was thirteen, I decided to try. Many of the other children at school taunted me, and I realized I was not ready to make a stand, and the community was not ready to accept diversity. That was the only time I attempted to wear a hijab until I moved to New York City.

New York became my saving grace. I moved here after I married, and I was amazed at the diversity and uniqueness of the people. I settled in Brooklyn, where I saw African-American Muslim women wearing the hijab. I admired their grace and beauty in their modest Islamic dress. No one eyed them or made remarks about their appearance. I began to reflect about my religion and culture. How could African-American converts embrace the religion I was born into when I could not practice it openly? I came to realize that New York City was a place accepting of every race, color, and creed; it was a place I could call home. After a great deal of soul searching, I decided to follow my heart and cover my hair. That was more than two decades ago.

What a difference growing up in New York City has made for my daughter. Five years ago, when she was nine, Shifa decided to wear a hijab to school one day. It was during Ramadan, the

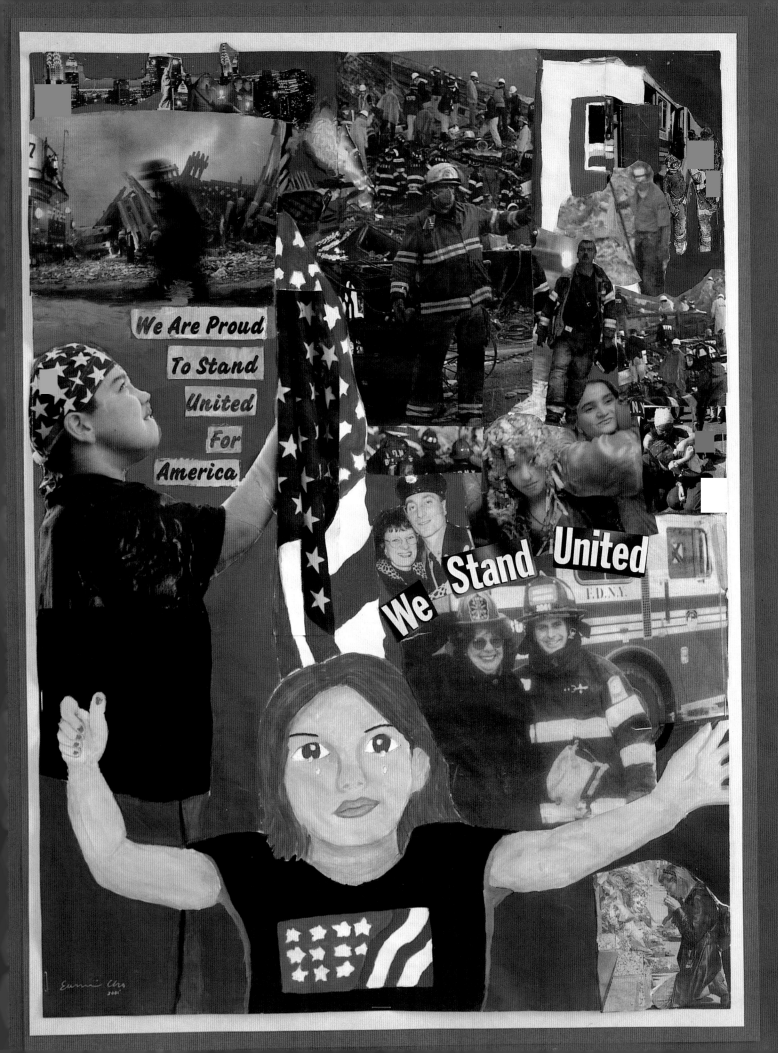

We Are Proud To Stand United For America

We Stand United

| Eunmi Cho, 14 years old. **Untitled.** 24 x 18"

month-long Islamic fast, and I spent the whole day worrying about the reactions she would face. I prayed she would not relive my experience. I remember her running into the house at the end of the school day, calling out to me. I was frantic because I did not know what to expect. To my relief, her classmates at P.S. 321 had been very compassionate. She reported, "Mom, everyone liked my hijab. They all said that I looked beautiful in it and that if it's what I want to wear, they support me one hundred percent." New York's diversity made this possible.

Shifa is fourteen years old now, and she can't imagine not wearing a hijab. She is a typical American girl whose two passions are music and talking on the phone with her friends. But after September 11, she also dealt with the struggles I faced every day; she was conscious of being stared at, and she wondered what people were thinking. After the attack, she was afraid to leave the house alone. To get her to school safely, I had to arrange for a private bus for her and some of her friends. Out of fear for her safety, I asked her to think about not wearing the hijab in public until things calmed down. Her response was emphatic: "Absolutely not. I'm not going to let anyone strip me of my religious right." Her courage and devotion made me very proud and reminded me of how much we are alike.

Growing up in New York City has made my children loyal and conscientious citizens who will do anything for the only country they know as home. My older son, Yousif, decided to join the United States Army three years ago. As a person who loves peace, I was torn, but we supported his decision. After the attack on the World Trade Center, I wished I had not. On September 11, he reported to his unit and was sent to Ground Zero. He was there for almost five months. In the beginning, he was part of the rescue mission, and I waited anxiously by the phone every night, hoping he would call to tell us he was safe. I worried about both his physical and his emotional well-being. In the days after the attack, when Muslims sometimes became scapegoats for many frustrated people, my concern was, and still is: How will others perceive him?

Will they recognize his deep commitment to his country?

I remember the first night Yousif came home after the tragedy. His presence at the front door was a relief, but I almost did not recognize him. What he had seen and experienced had aged him far beyond his nineteen years. He could have passed for his father's brother, not his son. When I asked what it was like at Ground Zero, he couldn't talk about it. They say it takes months and sometimes years before someone is ready to talk about this kind of experience. His struggle for a normal life is haunted by nightmares. Doctors tell us that his hair loss is due to mental stress and anxiety. The evil acts of others have stripped away my child's innocence on many levels. As a mother, my prayer for him is that God will replace the sights and sounds of destruction and death with visions of peace and harmony.

Along with being a mother, wife, and teacher, after September 11 I also became a busy community activist. With others, I developed several projects to safeguard my neighbors. I held open houses at my home, so that people within the community could get to know their Arab and Muslim neighbors on a social basis and could learn how much we all have in common. We arranged for escorts for people who were afraid in the streets and offered referrals to legal and mental health agencies. Most important, perhaps, was the curriculum project: expert educators from across the city developed aids for teachers to address the issues relating to Arabs and Muslims for distribution to all New York City schools.

What is essential now is for us to come together as a community and a country, to be educated and to educate others. We need to be reminded that there are people who do bad things, but there are many more people who do good things. We need to take pride in our diverse heritage because that's what makes New York and America unique. To overcome our fears, we must speak and listen to each other, making sure that no one's voice is silenced. We need to turn this tragic event into a way to build bridges with all communities that are affected. We owe it to our children, who are the future. ■■■

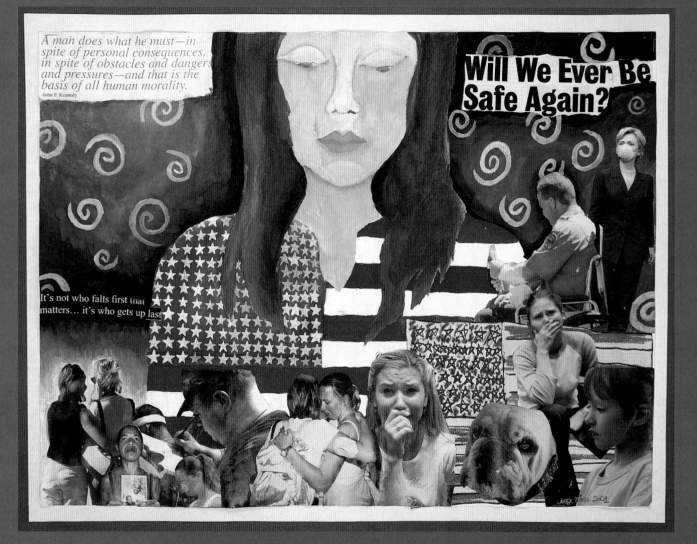

| Alise Vitale, 14 years old. **Lady Liberty.** 18 x 24"

"A man does what he must in spite of personal consequences, in spite of obstacles and dangers and pressures, and that is the basis of all human morality." —JOHN F. KENNEDY

| Chloe Cohn, 10 years old. **Untitled.** 17 ⅞ x 23 ¾"

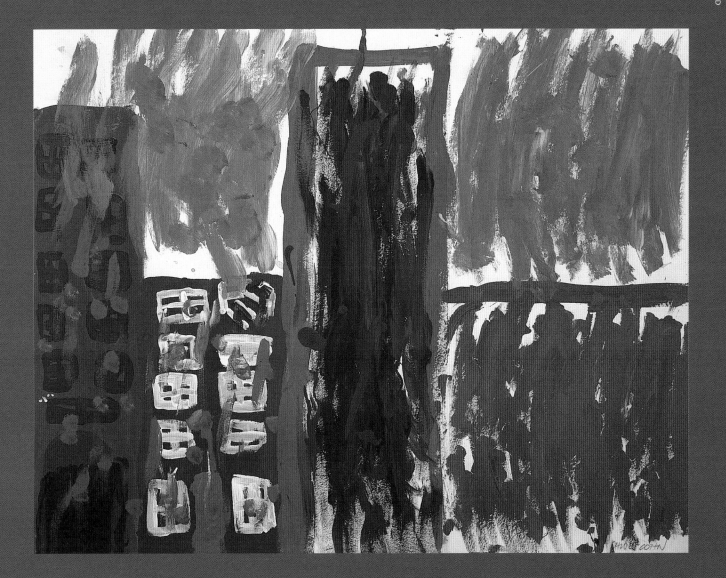

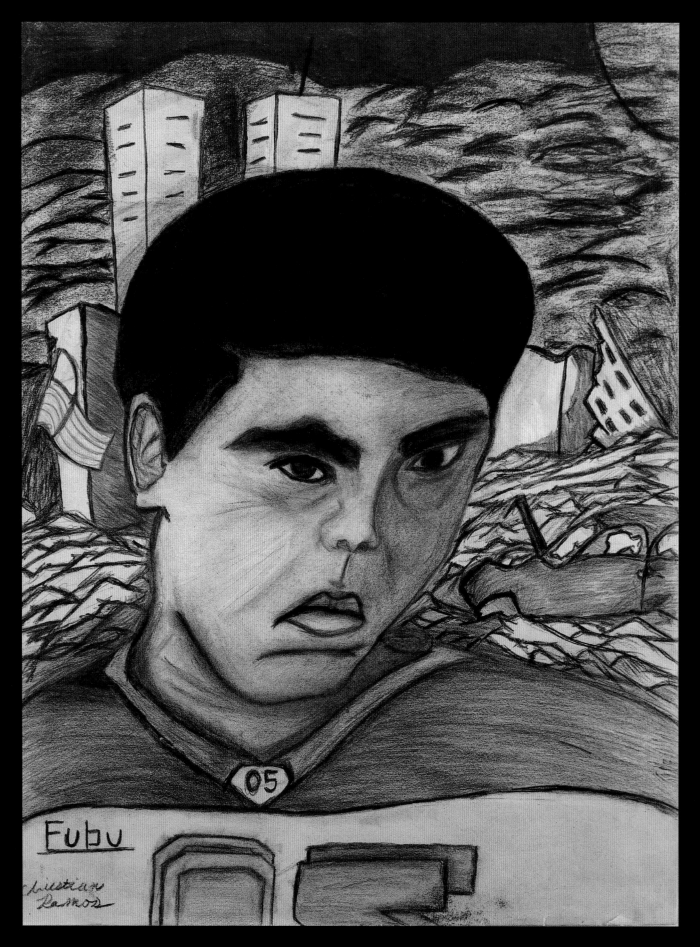

Fubu

Christian Ramos

| Christian Ramos, 16 years old. **The Rage.** 24 x 18"

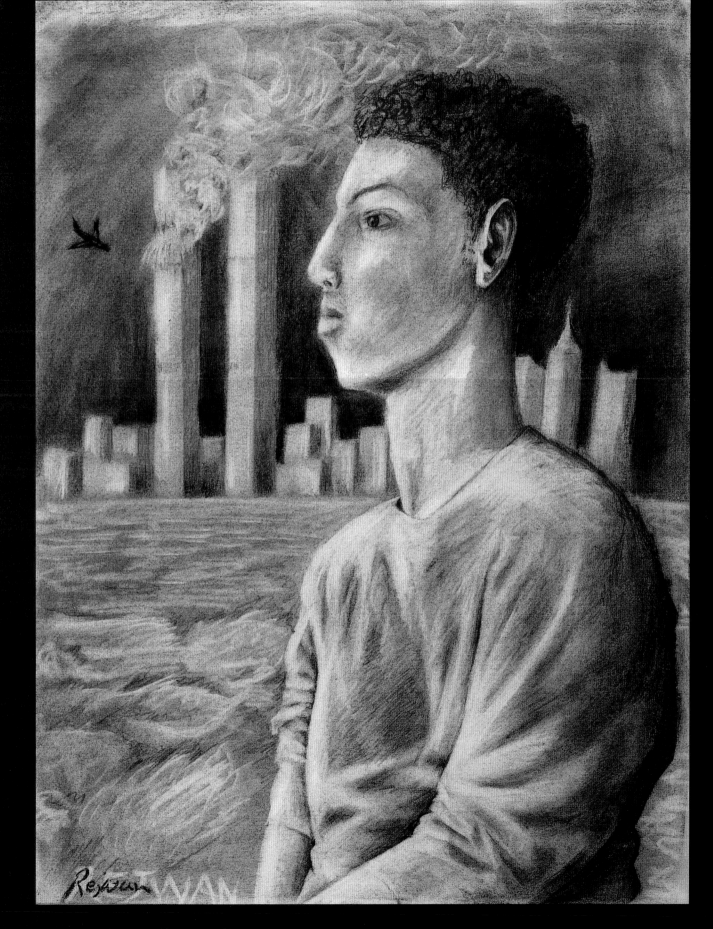

| Rejwan Ahmed, 16 years old. **A New World.** 24 x 18"

"I named this artwork *A New World* because at that time it changed everything."

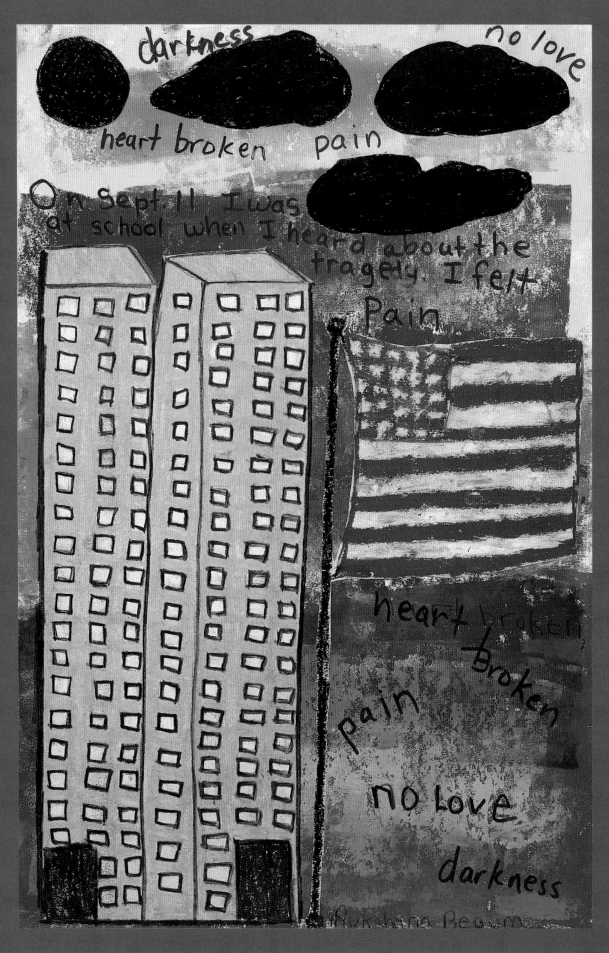

| Shanaz Begum Rahman, 11 years old. **Untitled.** 18 x 12"

| Merica Noel Suga, 11 years old. **Nervous.** 10 x 16 ⅞"

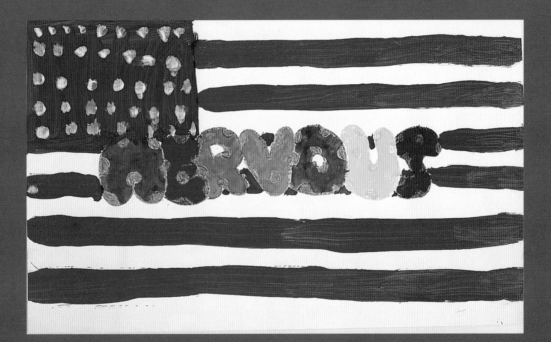

| Nesita Abreu, 9 years old. **Untitled.** 11 x 8 ½"

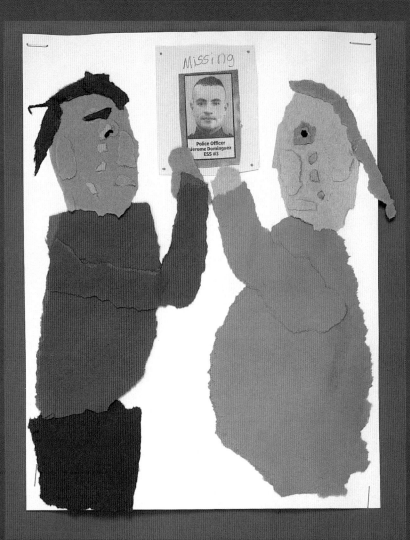

| Valery Chen, 17 years old. **Untitled.** 23 ¾ x 17 ¾"

"I wanted to express the pain and frustration of the people of our nation and New York in particular."

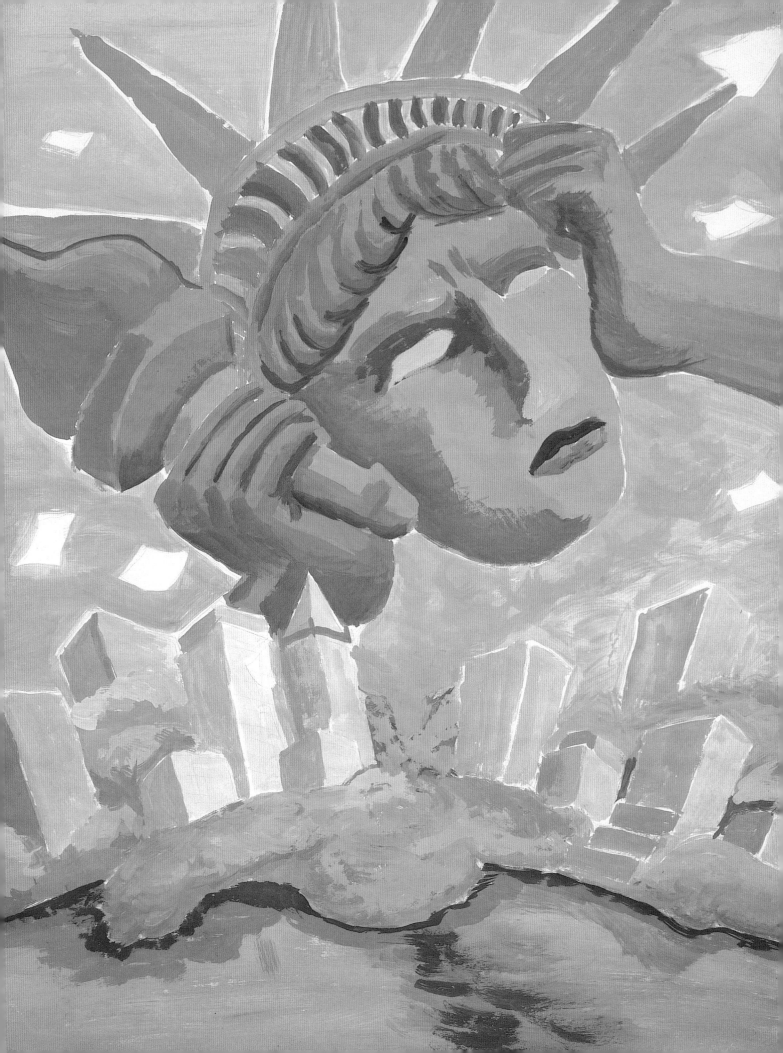

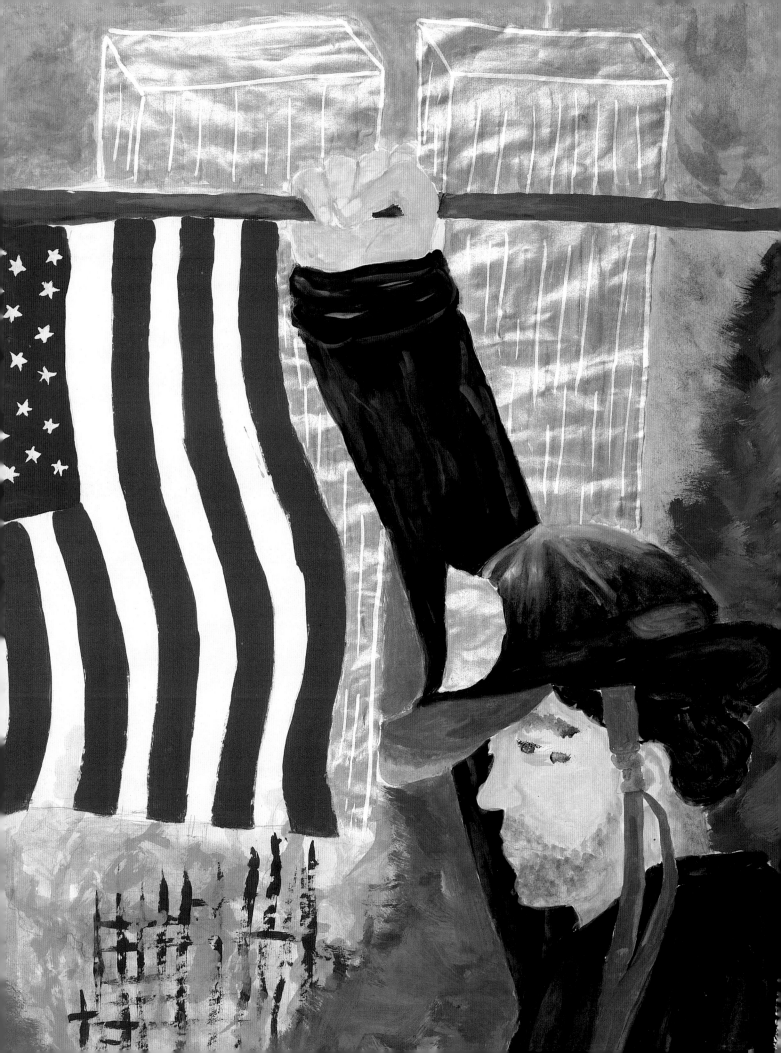

HEROES & HELPERS

Ewa Podgorska, 8 years old. **Fireman.** 22 ¾ x 17"

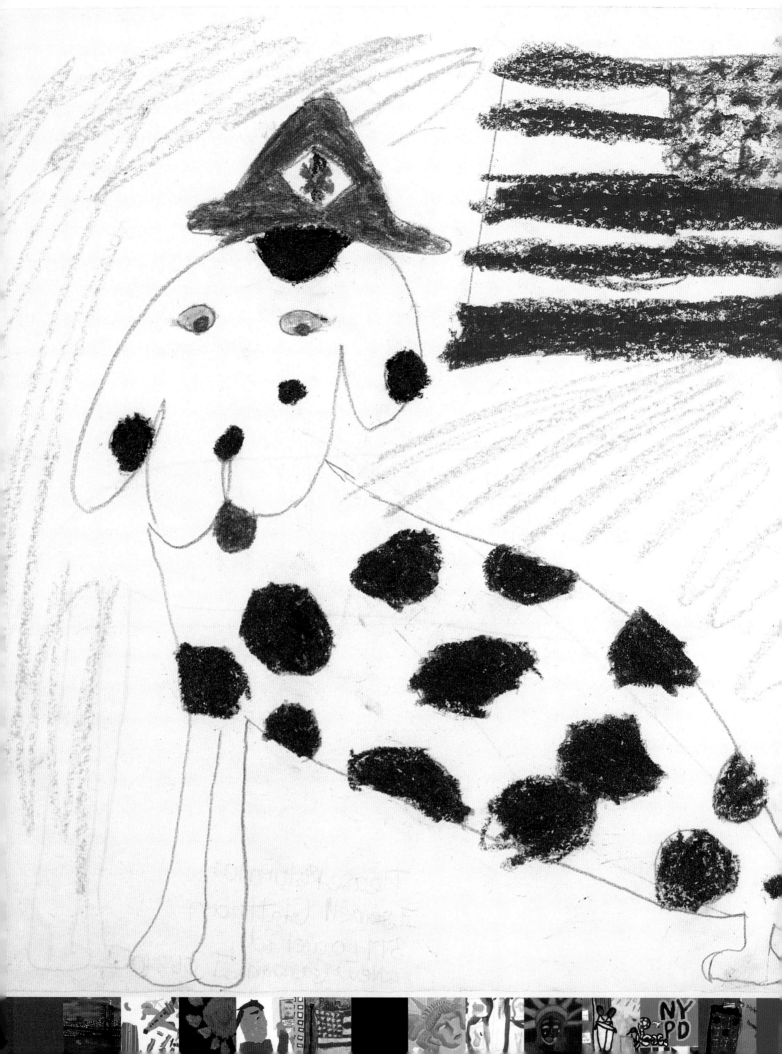

A New Friend at the Firehouse

JANE ROSENTHAL & CRAIG HATKOFF

In the post-9/11 world, holidays, traditions, and customs take on new meaning. In addition, just as the sensibilities for adults have changed since September 11, so have they changed for our children.

Shortly after September 11, our daughter Juliana, soon to be seven years old, decided to take her duck bank over to our local firehouse. There, she met retired firefighter Lieutenant Vic Navarra, who graciously accepted her gift and gave her a tearful embrace, recorded in the local paper.

Halloween was then upon us. Juliana, who had recently decided to be a fairy, was having second thoughts about her costume choice. After great deliberation, she announced that she now wished to be a firefighter for Halloween and planned to bring cookies to the firehouse. Perhaps she might even see her new friend, Lieutenant Navarra.

So on Halloween, the family set out for Ladder 35, Engine 40. There, Vic unexpectedly opened the door. The expressions on both Juliana and Vic's faces were priceless. We had intended to stay for a few minutes but lingered for more than an hour. Juliana and her sister Isabella had found a safe haven with their new guardian angels—a half-dozen firefighters from Ladder 35, not to mention Zeke, the firedog.

Returning home, Juliana announced that this had been the best Halloween ever. She felt safe again—for the moment. She asked if we could do this every year—and undoubtedly it will become our new family tradition—bringing a very deep and different meaning to Halloween. ■■■■

| Isabel Glatthorn, 8 years old. **Sparkly Spots Proud To Be An American.** 12 1/4 x 17"

"Dalmations help people to be found and cheer up the Fireman. He's an American, too."

| Emily Ban, 11 years old; Ace Bouchard, 12 years old; Daniel Brumer, 11 years old; Adam Dale; Rima Dodd, 11 years old; Emma Gabriner, 11 years old; Kurt Henlin, 12 years old; Miles Johnson, 12 years old; Leah Koren, 11 years old; Michaela Kupfer, 12 years old; Aliza Lederer-Plaskett, 11 years old; Amanda Lerner, 11 years old; Harry Morgenthau, 12 years old; Ikuno Naka, 11 years old; Simone Paasche, 11 years old; Skye Parr, 11 years old; Maria Psathas, 11 years old; Sophia Rehm, 11 years old; Gabe Salzman, 11 years old; Billy Shapiro, 12 years old; Ben Stone, 11 years old; and Anonymous (2). **Untitled.** 46 ½ x 133"

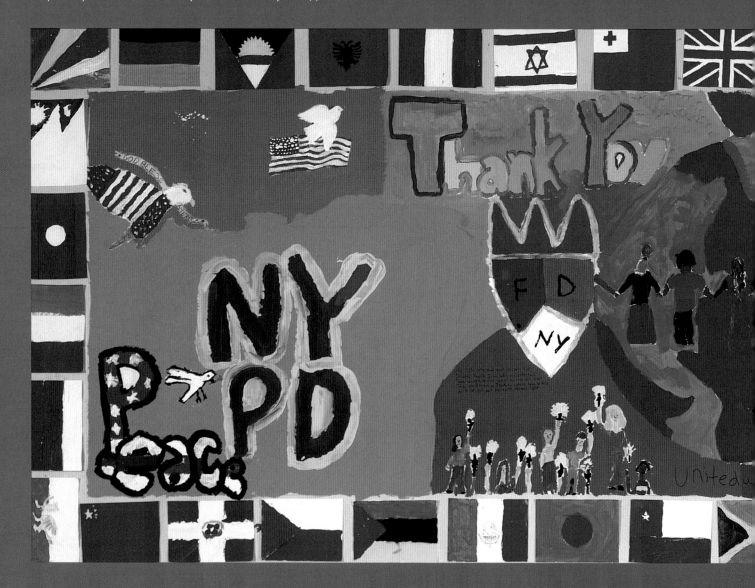

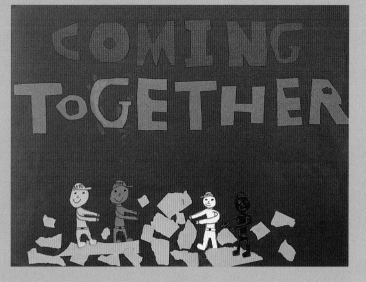

| Matthew Sussman, 12 years old. **Untitled.** 17 ⅞ x 23 ⅞"

"I did this because seeing people of all different races coming together is really amazing."

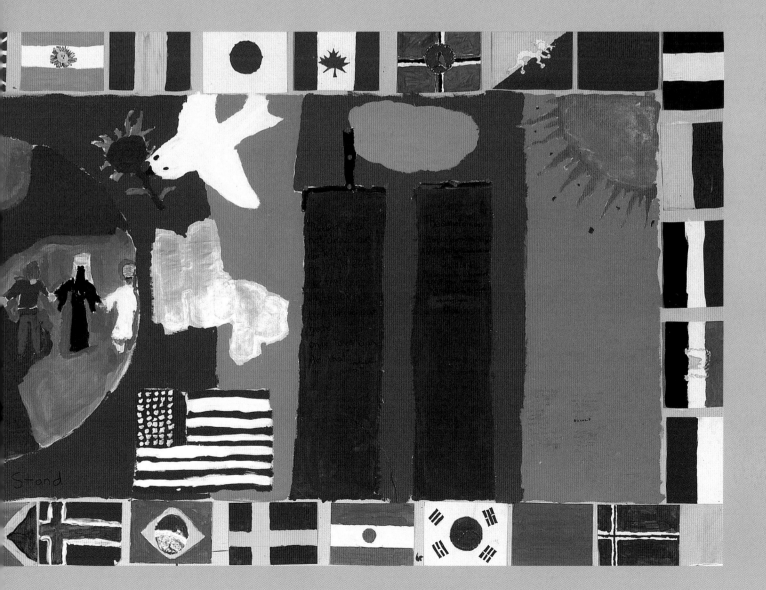

"I feel sad because dogs have sacrificed themselves for other people. And their tails got squashed and their ears got cut off."

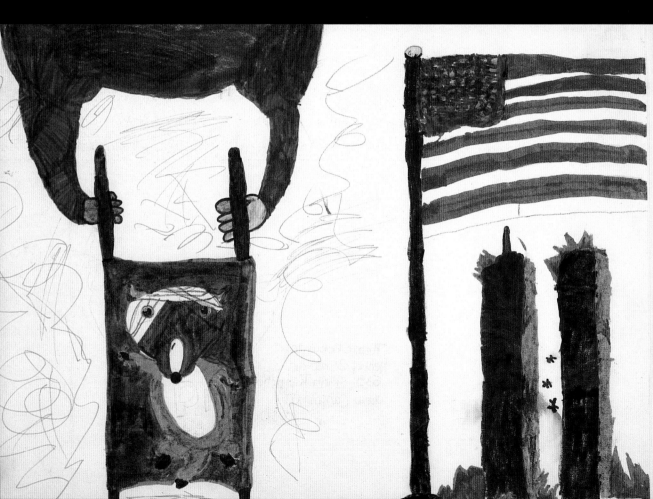

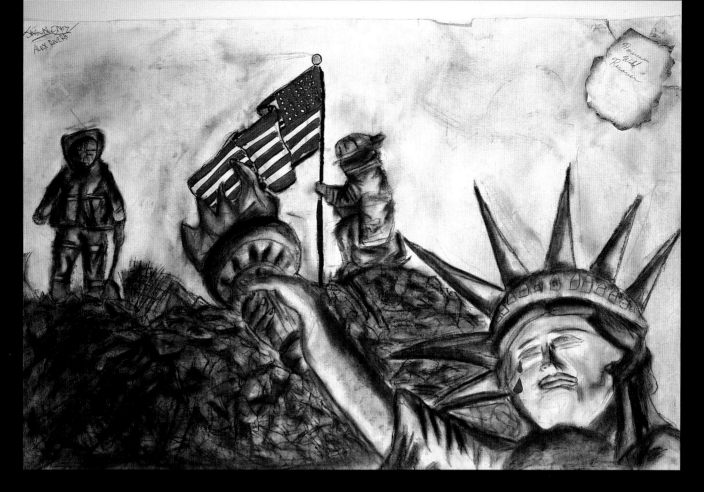

| Jason Ortiz, 13 years old; and Alexander Rivera, 14 years old. **Even the Statue Cries**. 26 x 40"

"Shortly after the tragedy I kept seeing pictures and drawings on the Internet. Then I remembered seeing the photo of the fireman holding the U.S. flag. In art class at school I saw a picture of the Statue of Liberty and then I just started drawing. While I was drawing the Statue of Liberty, Alex started drawing the fireman in the background. Neither one of us likes to use color when we draw, so that's why it's black and white. To make the flag and the tear stand out we added color."

| OVERLEAF: Justin Andreadis, 10 years old; Tynell Dreux, 10 years old; Jazmyne Muldrow, 11 years old; and Jorge Munoz, 10 years old. **WTC Tragedy.** 17 x 22 ⅞"

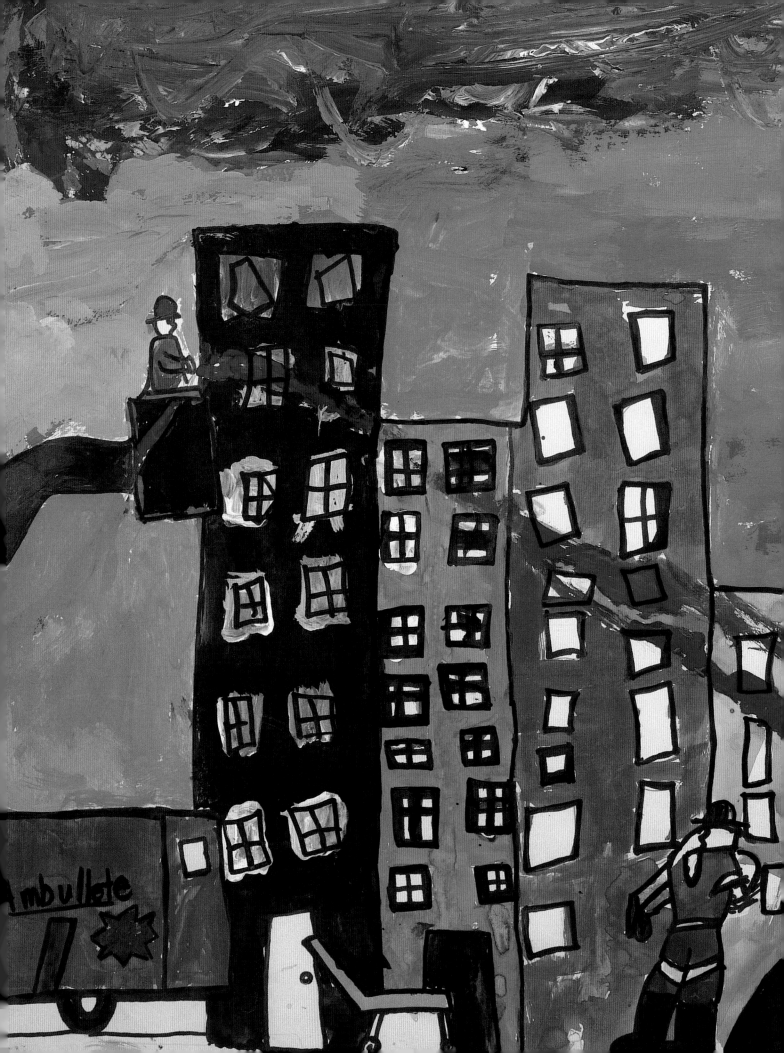

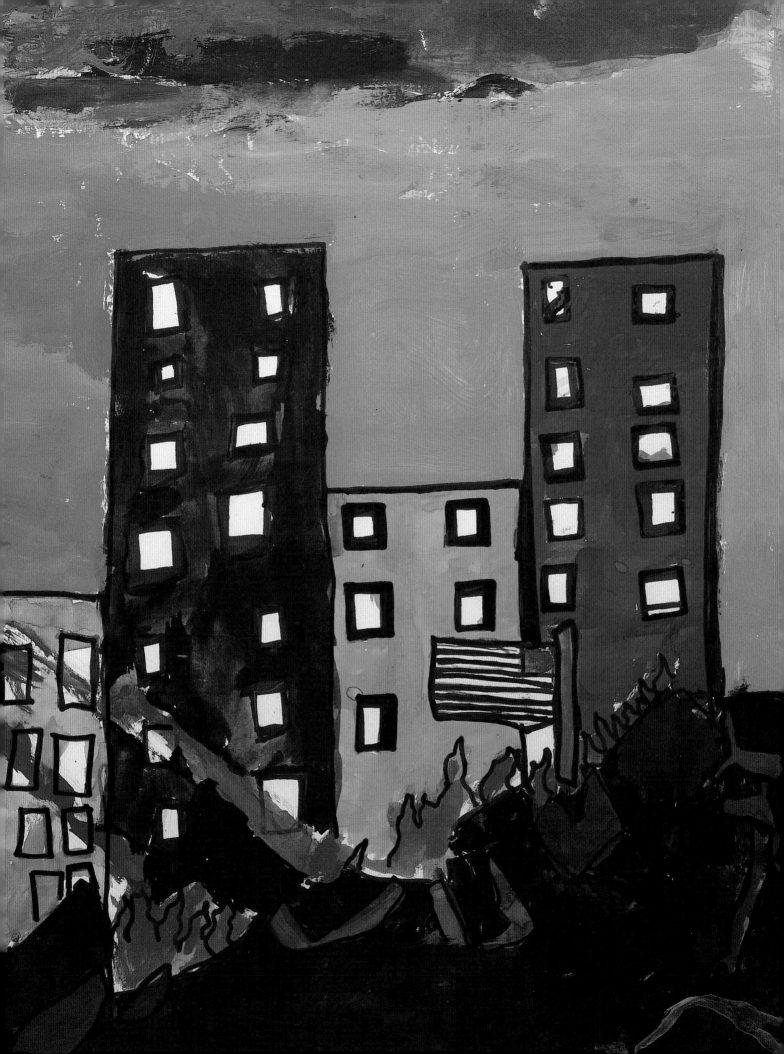

We suffered a tremendous loss. The attack on America and my city shook the world. As a retired New York City Fire Lieutenant, I knew instantly that I needed to be with my family at home, and my family in the NYFD. First, I spoke to my daughters and my wife. They assured me that they were safe and well. Then I called the men of Ladder 35 and Engine 40. The news was not as good. Both companies had responded to the World Trade Center attack, and thirteen of the brothers were now reported missing.

A city that seemed to crumble on the morning of September 11 soon began to rise like a gentle giant from the ashes of the twin towers. New York, a city often thought of as callous and impersonal, awoke to show its true colors. From river to river and from sea to sea, the citizens of the city and figuratively and literally.

The days and weeks that followed were filled with emotion. Twenty-four hours a day, people from all walks of life called, wrote, and visited our firehouse at New York's Lincoln Center. These people brought clothing, food, and donations. They ate with us, they cried with us, and they prayed with us. A shrine of flowers and candles filled the sidewalk in front of the house.

The visitors who affected me the most were the children. Children from the local schools baked cookies and wrapped them with messages to the firefighters. Many of the children drew pictures to show their sorrow and support. The firefighters, who rarely slept

One Sunday morning while I stood in front of the firehouse, a six-year-old girl named Juliana appeared at my side. She had come to give us a gift—her little duck bank with all of her savings and a few dollars from her mom and dad, to be given to the children of our lost firefighters. With tears in my eyes, I humbly accepted the bank. This act of love and selflessness formed a bond that has given me the strength to carry on.

The future that seemed so bleak and dark now fills me with hope because of these children. Life will go on. And our world is better and stronger than ever before. God bless the children. Through their eyes we gain our strength.

| Vivian Ng, 16 years old. **Firefighters Standing Strong.** 13 ⅜ x 11"

"The firefighter represents all the heroes of this event. His sadness is shown by the tilt of his head. However, he still holds the flag with honor and pride. The flag represents the nation's strength as they overcome the tragedy."

| OVERLEAF: Mariana Smith, 13 years old. **Untitled.** 11 ⅞ x 17 ¹⁵⁄₁₆"

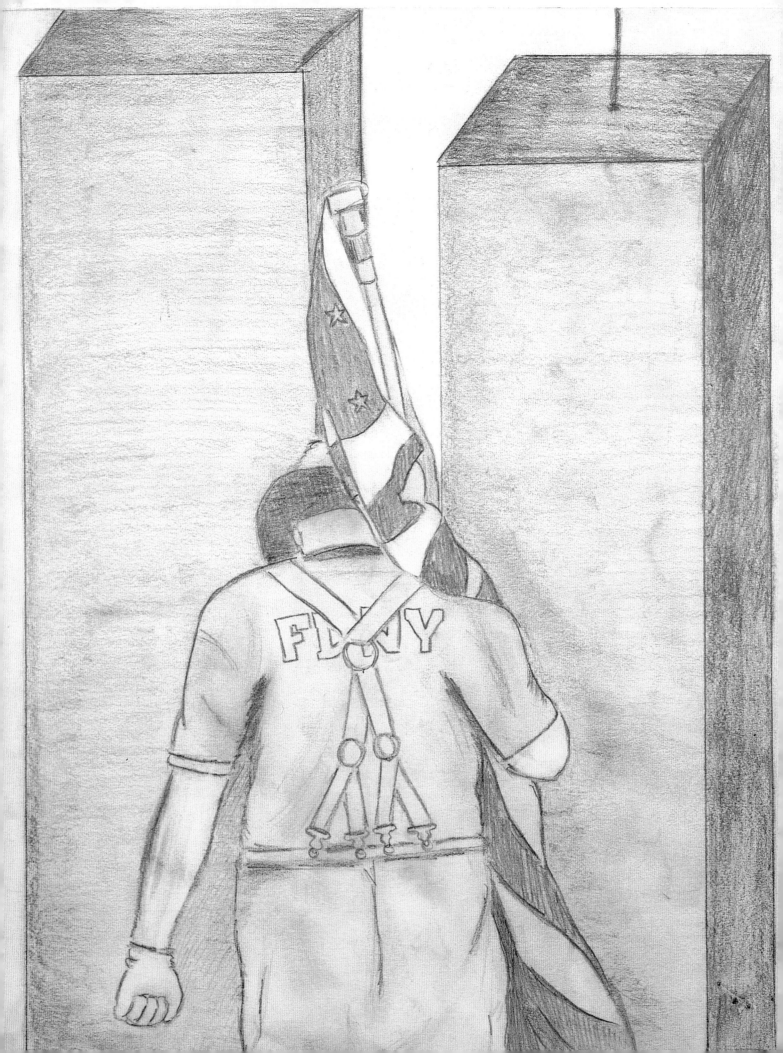

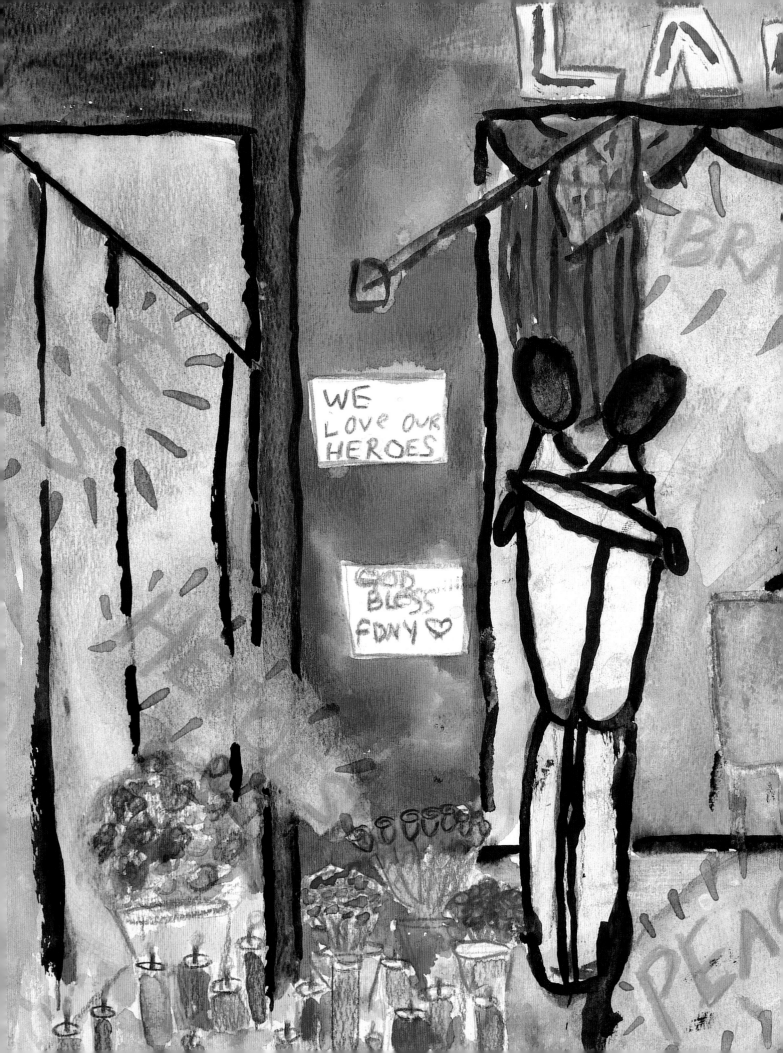

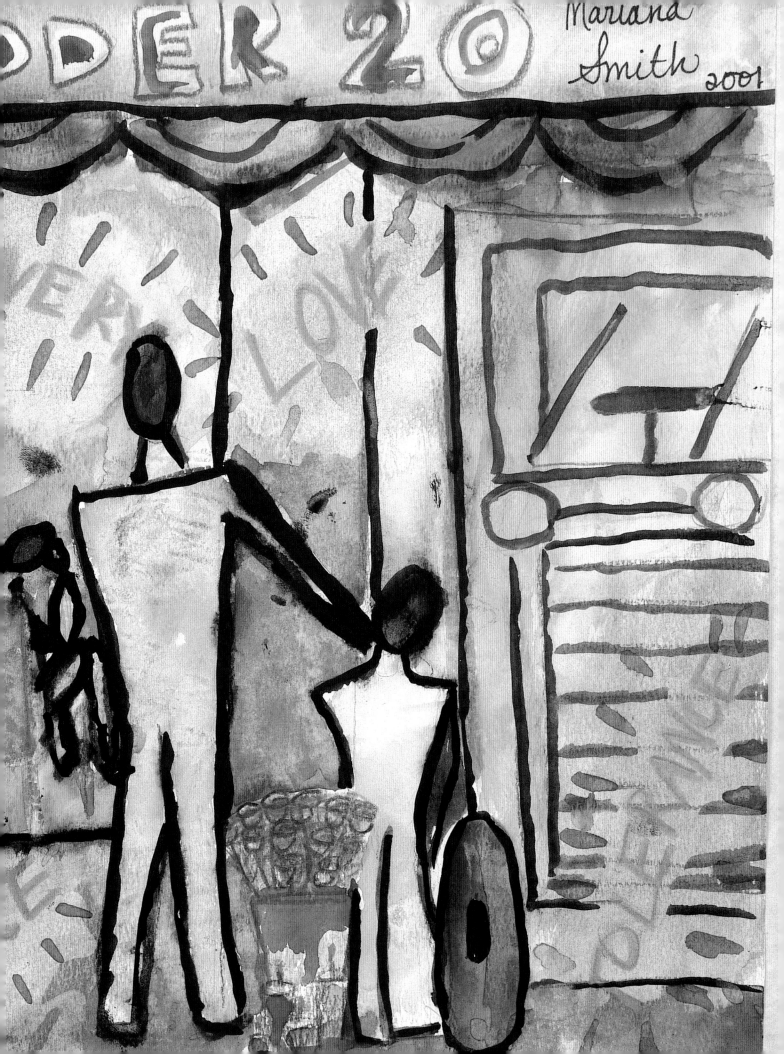

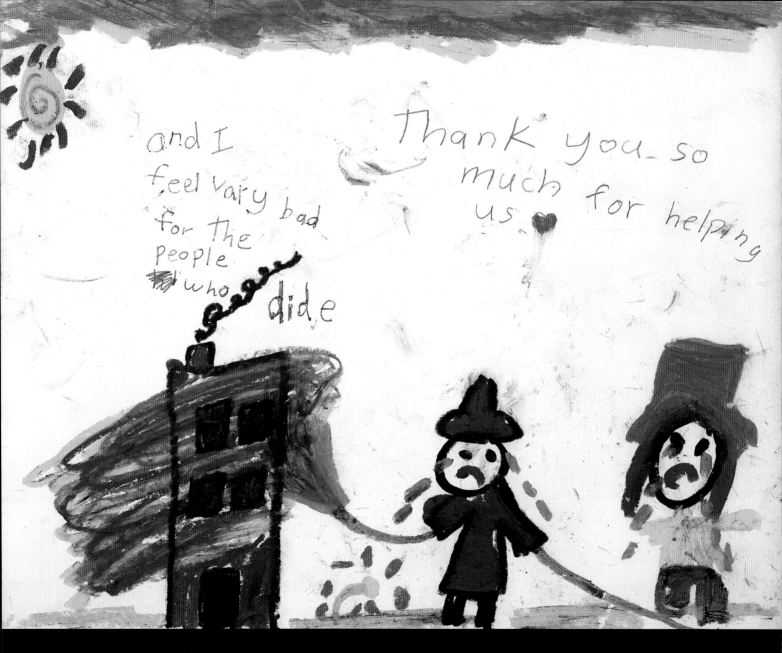

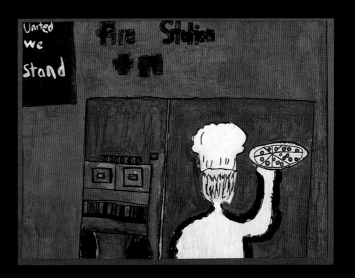

| Kalabe Haile, 10 years old; Nicholas Mastrocola, 10 years old; Sasha-Kay Powell, 11 years old; and Elizabeth Tassone, 10 years old.

Untitled. 21 ⅞ x 28"

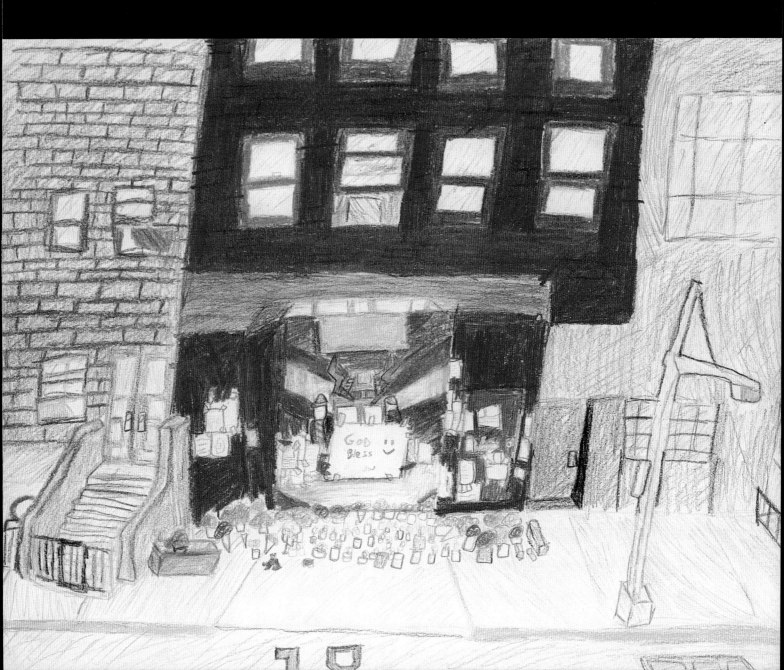

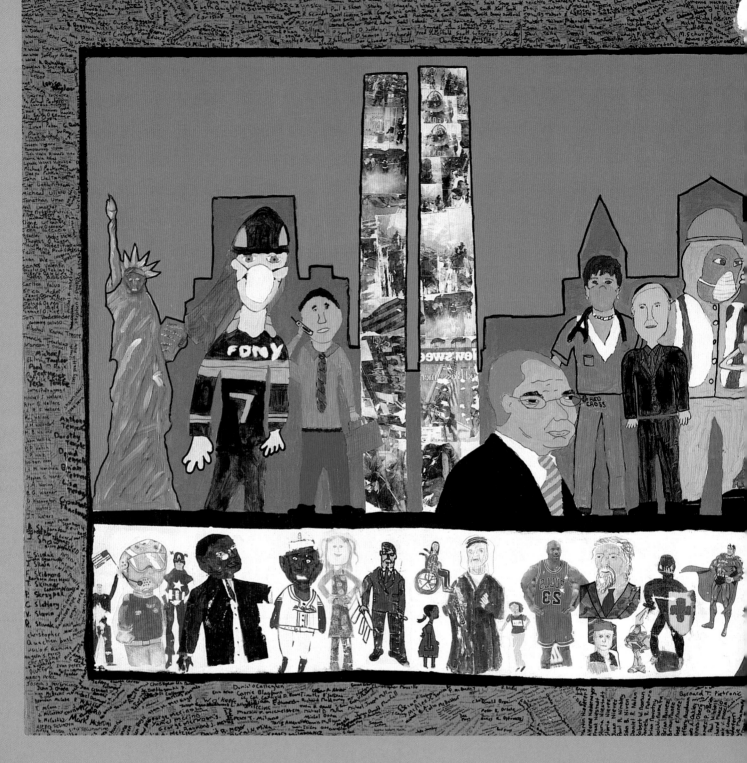

Rachel Abady, 12 years old; Jenny Ajl, 13 years old; Tal Akabas, 12 years old; Sara A. Arrow, 13 years old; Eugene Bardosh-Rabina, 11 years old; Sarah Bayefsky-Anand, 12 years old; Alex Beer, 12 years old; Sarah Belfer, 12 years old; Hilla Benzaken, 13 years old; Etan Berkowitz, 14 years old; Gdaly Berlin, 13 years old; Nicole Blanck, 13 years old; Franci Blattner, 14 years old; Marcy Blattner, 12 years old; Aaron Blumenstein, 13 years old; Yoni Bokser, 13 years old; Orli Brodie, 11 years old; Gabriela Bronstein, 12 years old; Micaela Bronstein, 13 years old; Joshua Budofsky, 13 years old; Sharon Bukspan, 13 years old; Norman Chernick-Zeitlin, 13 years old; Shuki Cirlin, 13 years old; Jeremy Cohen, 12 years old; Karyn Czapnik, 13 years old; Alexander Daar, 12 years old; Jacob Doctoroff, 14 years old; Ezra Dreiblatt, 13 years old; Manya Ellenberg, 13 years old; David Fell, 13 years old; Rebecca Fishbein, 12 years old; Ariel Benjamin Fisher, 14 years old; Jonah Fisher, 12 years old; Michal Flombaum, 13 years old; Julia Friedman, 12 years old; Ilana Gatoff, 12 years old; Nessa Geffen, 13 years old; Dafna Gershoony, 12 years old; Louis Gilbert, 12 years old; Ben Gitlin, 13 years old; Ezra Glenn, 11 years old; Ori Golan, 12 years old; Solomon Goldberg, 13 years old; Eliana Goldstein, 13 years old; Benjamin Gottesman. 12 years old; Suzanna Grobman, 11 years old; Rebecca Guenoun, 11 years old; William Herlands, 10 years old; Arielle Himoff, 13 years old; Sophia Holtz, 12 years old; David Inkeles, 12 years old; Katy Joseph, 12 years old; Noa Kasman, 11 years old; Sharone Kattan, 12 years old; Melanie Kimmelman, 11 years old; Andrew Kisch, 11 years old; Morris Kolontynsky, 11 years old; Jacob Kose, 12 years old; Liviya Kraemer, 13 years old; Danny Landau, 14 years old; Paula Laytner, 13 years old; Allison Leifer, 12 years old; Adin Lenchner, 12 years old; Nisan Lerea, 12 years old; Lee

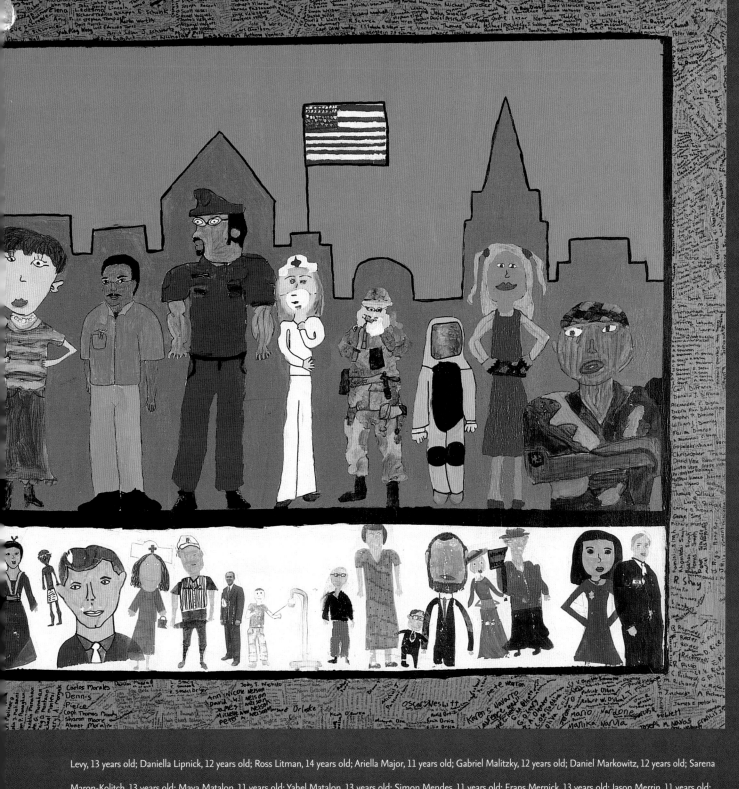

Levy, 13 years old; Daniella Lipnick, 12 years old; Ross Litman, 14 years old; Ariella Major, 11 years old; Gabriel Malitzky, 12 years old; Daniel Markowitz, 12 years old; Sarena Maron-Kolitch, 13 years old; Maya Matalon, 11 years old; Yahel Matalon, 13 years old; Simon Mendes, 11 years old; Frans Mernick, 13 years old; Jason Merrin, 11 years old; Andrew Milstein, 12 years old; Michelle Moser, 12 years old; Sharon Jane Moskovits, 12 years old; Ruthie Nachmany, 12 years old; Aaron Nathan, 14 years old; Daniel Nathan, 11 years old; Maddie Neufeld, 12 years old; Yaniv Oliver, 13 years old; Leah Oppenheimer, 11 years old; Gabriel Paley, 11 years old; Augustin Peytchinov, 13 years old; Rebeka Racz, 12 years old; Emma Ramat, 11 years old; Sarah Rebell, 12 years old; Mickey Reiss, 12 years old; Felicia Rosenfeld, 12 years old; Stefani Rubenfeld, 11 years old; Danielle Rubin, 13 years old; Maya Rubin, 13 years old; Melissa Rutman, 12 years old; David Sacks, 12 years old; Ilana Schack, 12 years old; Eliana Schleifer, 12 years old; Benjamin Schwarz, 13 years old; Aliza Sebert, 12 years old; Aviv Sharabi, 12 years old; Victor Shelden, 14 years old; Elliot Sion, 12 years old; Allison Skakel-Chernov, 12 years old; Ezra Smyser, 13 years old; Eitan Sosner, 11 years old; Naomi Sosner, 13 years old; Dina Spanbock, 12 years old; Sabrina Spiegel, 14 years old; Sebastian Stalman, 13 years old; Hallie Swidler, 11 years old; Dalia Terry, 11 years old; Isaac Toussie, 13 years old; Jacob Udell, 12 years old; Jon Watkins, 13 years old; Catherine Weiner, 12 years old; Benjamin A.M. Wexler, 12 years old; Danielle Wiener-Bronner, 13 years old; Max Winograd, 11 years old; Rebecca Wolff, 13 years old; Taylor Yaroslawitz, 11 years old; Ariel Yotive, 13 years old; Kayla Zalcgendler, 13 years old; Sara Zalcgendler, 11 years old; Ronit Zvi, 11 years old; and Anonymous (9). **Skyline of Heroes.** 48 x 96 1/4"

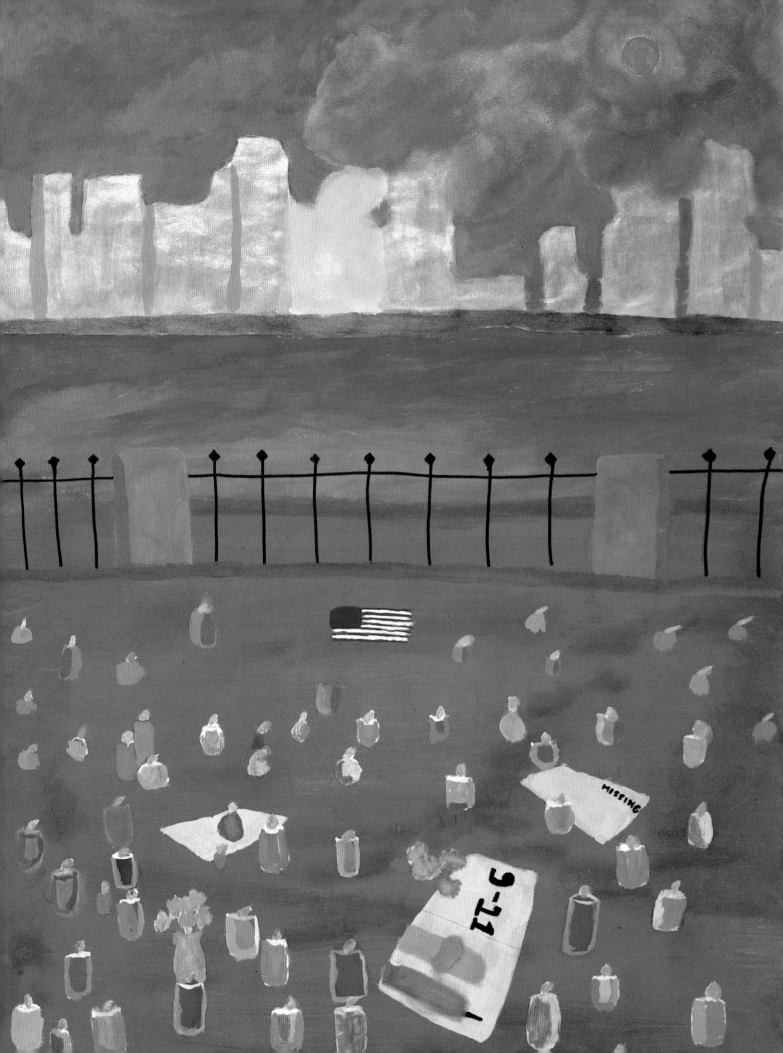

MEMORIES & TRIBUTES

| Wanda Martinez, 17 years old. **Mourning Sun.** 23 ¾ x 17 ¾"

"Creating this work helped me release all the stress that I had inside of me.
I hope this painting helps others, as it has helped me."

Spiritual Resistance Through Art

RABBI PETER J. RUBINSTEIN

According to biblical tradition, Bezalel was chosen to build the Ark of the Covenant and to fashion the tabernacle in which God and the people of Israel met while they wandered through the desert. There is no evidence that Bezalel had any previous experience. Nor is there testimony praising his artistic capability prior to God's directive to build the tabernacle. The only credentials ascribed to Bezalel were these attributes: he had understanding, knowledge, and wisdom of the heart and the spirit of God. What an amazing combination of virtues!

What he fashioned became the center of the people, the place where they and God would meet, where the people worshipped, where they came for safety and community. He created magnificent expressions of faith.

The drawings of children after September 11 urge us to discover equivalent expressions of faith, compassion, and loveliness. Spurred by a combination of mind and heart, art becomes a powerful form of spiritual resistance. These pictures proclaim that there is beauty in the world, that spirit and strength are alive and vibrant. Expressions of goodness combat those who would destroy and vanquish.

And we who admire those who put their souls down on paper and canvas with crayon, paint, and pencil embrace the best of humanity. We know that where a creative God is at work, beauty exists. On these pages, we rediscover our faith. ■■ ▬▬

| Jie Zheng, 18 years old. **Untitled.** 16 ¾ x 13 ⅞"

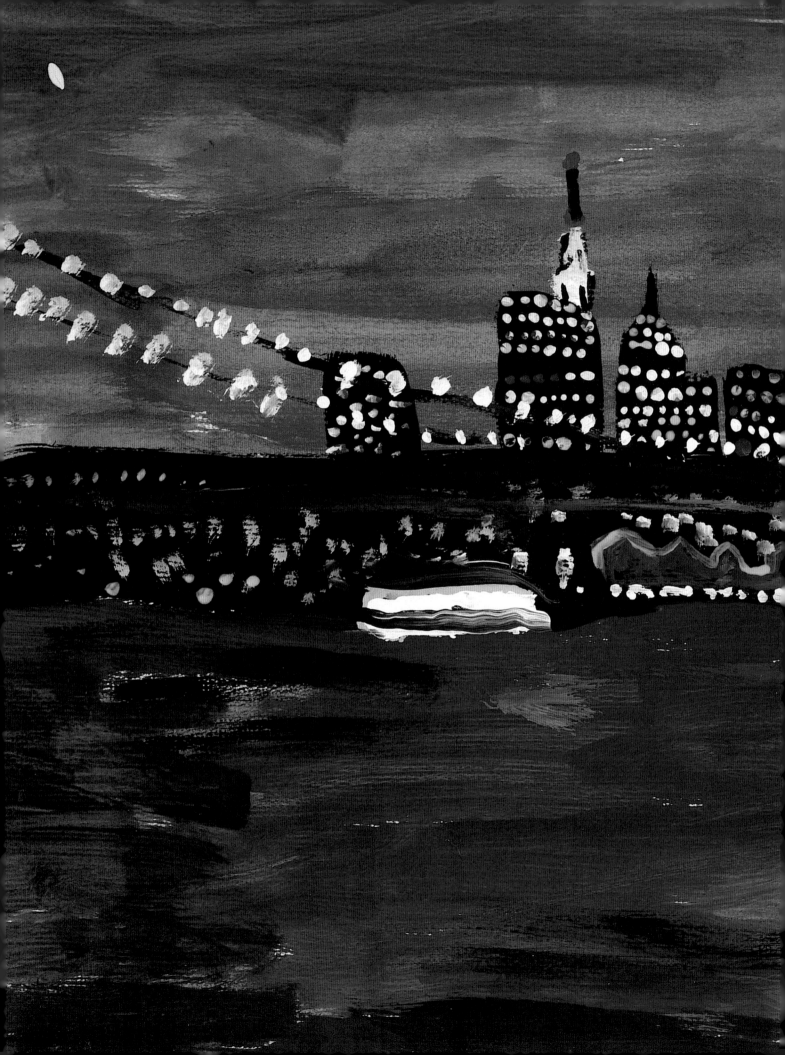

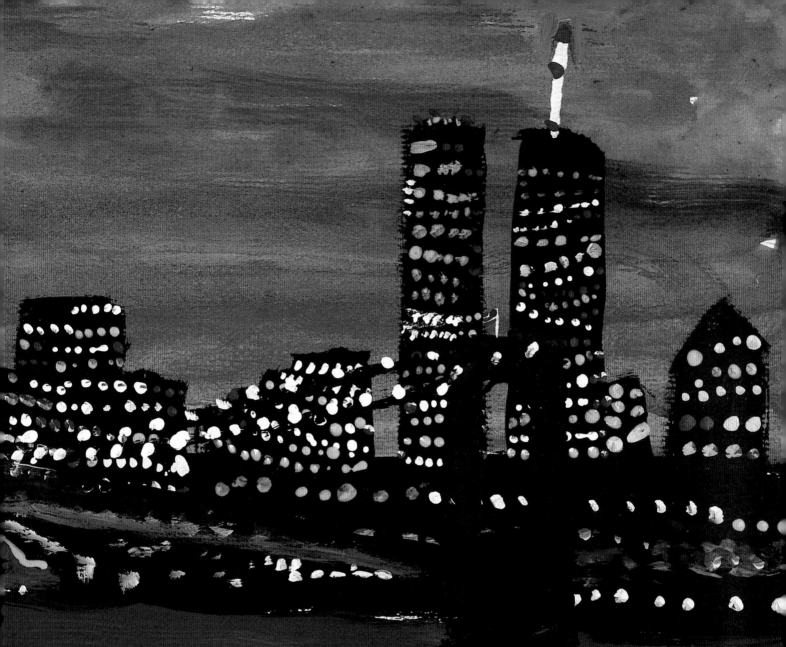

Yvette Miller, 8 years old. **Untitled.** 12 ⅝ x 19 ⅛"

"I felt sad because the Twin Towers were my favorite towers.
To me, the Twin Towers were the face of New York."

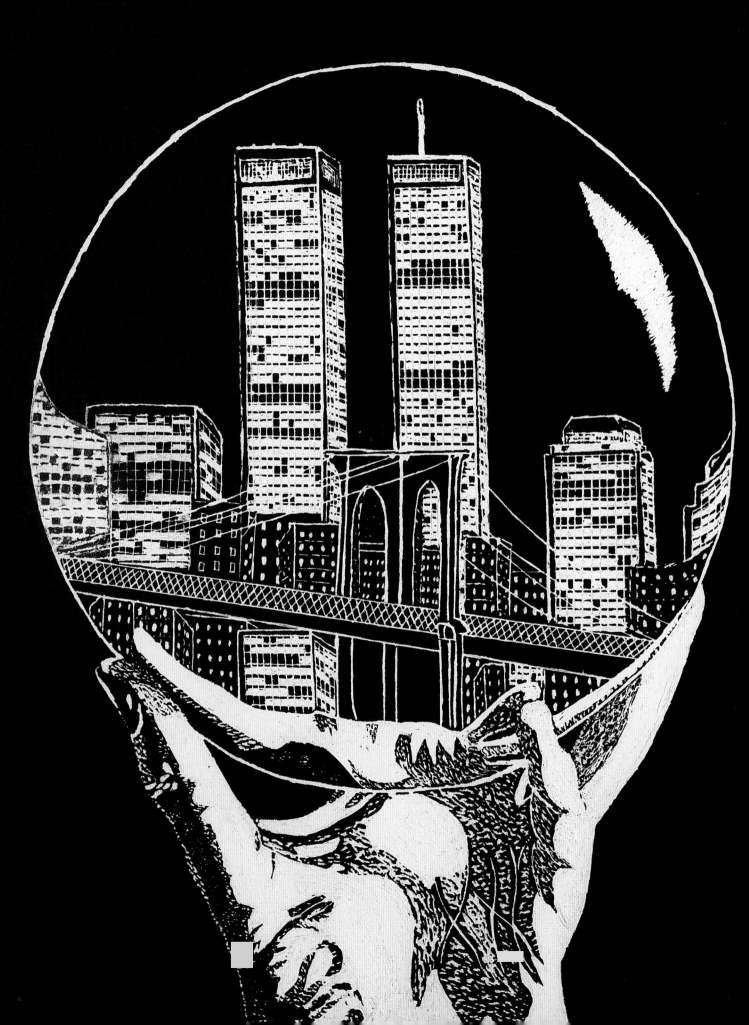

| Andrew Emil, 11 years old. **Memorial.** 12 x 9"

"My father worked on the 106th and 107th floors of the WTC Building Number One. Luckily he wasn't there."

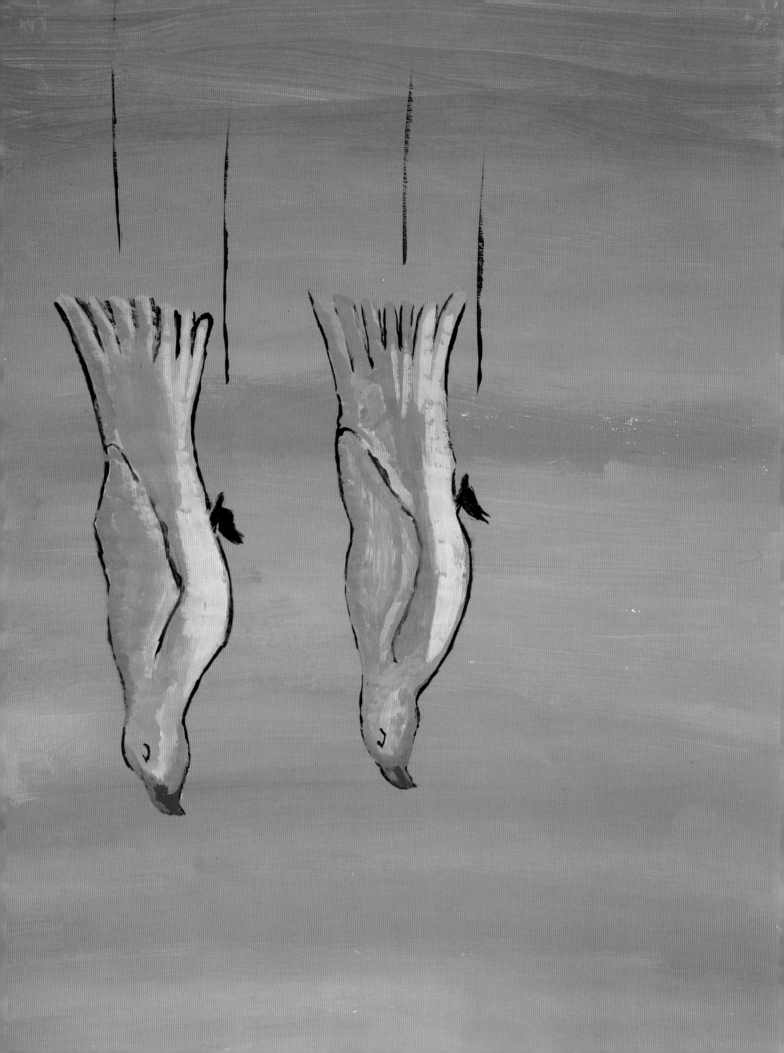

Memories Will Shape the Future

ARTHUR L. CARTER

So much that informs the great works of art of our time comes from the innocence, humor, primal joy, fear, and innate sense of humanity that children typically have. And so much of the art made by children since September 11 expresses that same unguarded set of instincts: the crayoned drawings of planes, explosions, towers, tears, and shock come from some of the same places in the heart that we find in *Guernica*. As Picasso himself said of children, "It took me a lifetime to learn to draw like them."

Many adults have tried to respond to the day, but few have done it as eloquently as our children. What a lesson! Their instincts have an emotional incisiveness that few adults can match. And perhaps one of the only possible benefits from this terrible incident is just that: in creating artistic responses to the day to which they woke, the children of 2001 have made a time capsule, a bequest to their own future. They have memorialized and vouchsafed their feelings, so that someday the art they made as children can inform the adults they will become, lighting the future of our society in a living archive of their own optimism and exuberance.

| Babul Miah, 17 years old. **Empire Fallen.** 23 ¾ x 17 ¾"

"This painting shows the Towers...falling from the sky."

"A memory of lower Manhattan."

| Reed Coston, 13 years old. **Untitled.** 11 ⅞ x 17 ⅞"

| Darren Palmateer, 11 years old. **Untitled.** 12 x 17 ⅞"

| Anonymous, 12 years old. **Untitled.** 24 x 17 ¾"

| Aliza Molgora, 7 years old. **Untitled.** 19 ⅞ x 15 ⅞"

"I felt really sad when the Twin Towers fell down. I hated when people were killed by the fire. I really hated when that person jumped out his window and lost his life. I felt sad when kids lost one or more parents. I miss the Twin Towers a lot. I wish that there was no war or nothing to hurt someone or something. In the middle of the painting there is an angel and it is making magic dust so the Twin Towers will never fall."

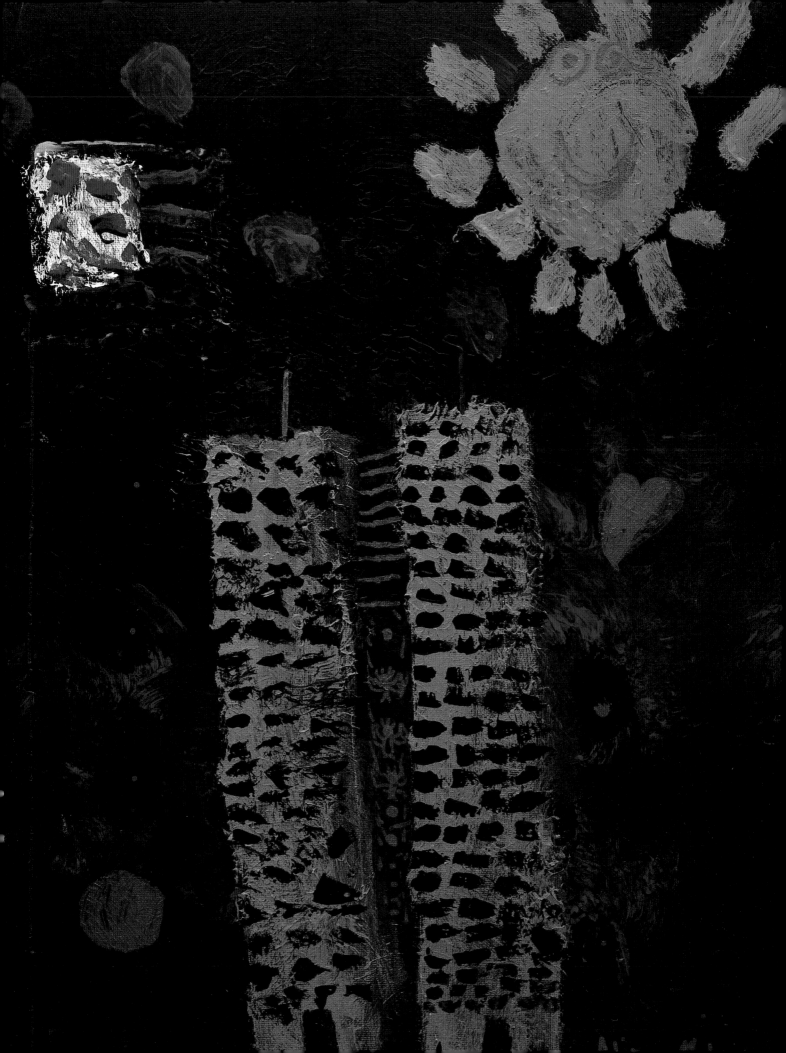

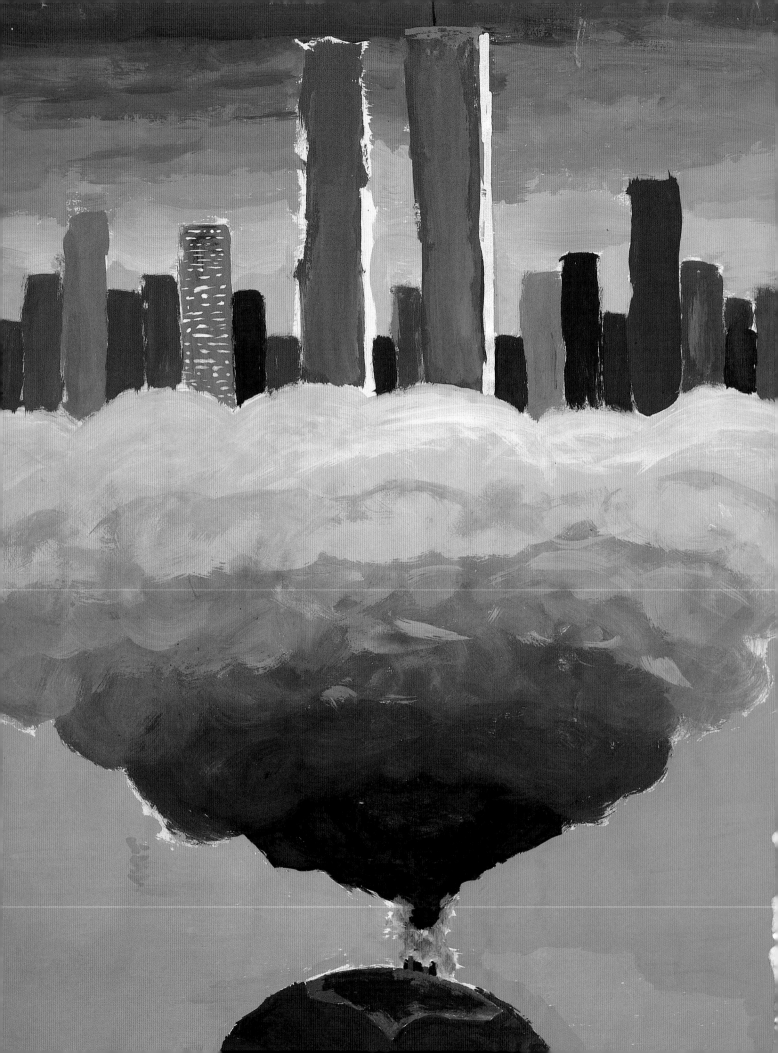

| Master John Harrattan, 18 years old. **Before and After 9/11/01.** 14 x 11"

| Catherine Ormaeche, 17 years old. **Untitled.** 16 ⅞ x 13 ¹⁵⁄₁₆"

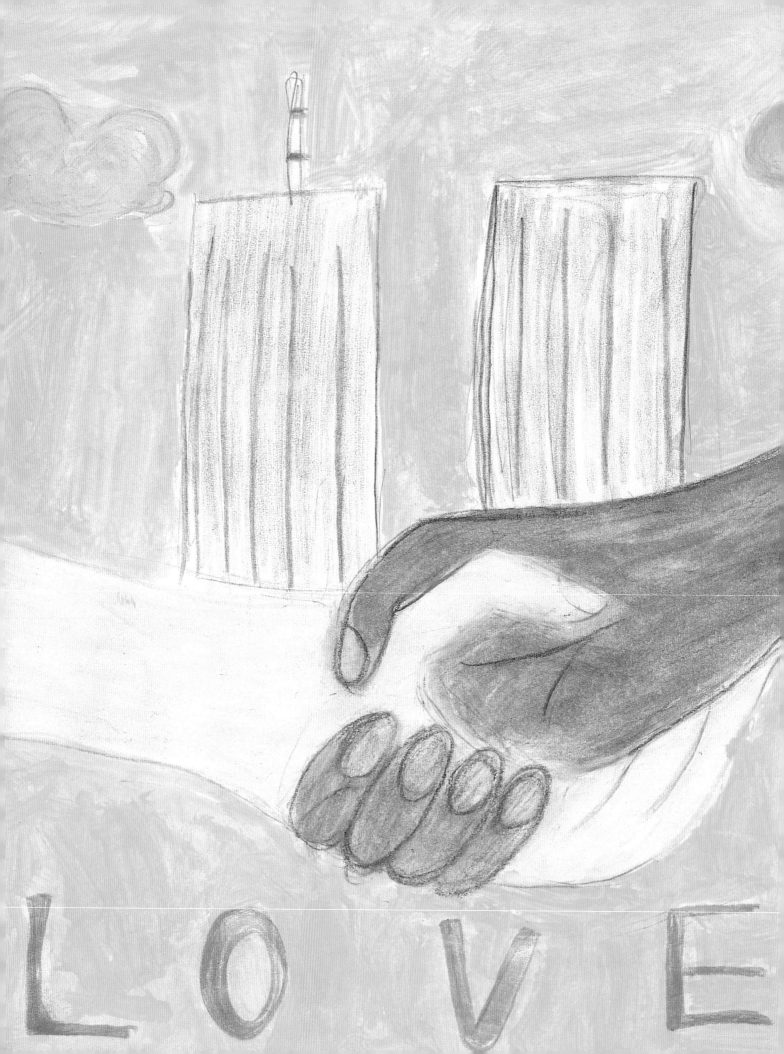

HOPE & RENEWAL

| Soobin Lim, 13 years old. **The Power of Love.** 8 ½ x 11"

"When the World Trade Center was destroyed, many people started to cooperate more than ever before. I drew people's hands working and loving one another."

The Resilience of Our Children

SENATOR JON S. CORZINE

There is no question that our lives and our country changed on September 11. This is particularly true for the most vulnerable—our children. No matter how hard we may try as parents, caretakers, and teachers to shelter our children from this pain, their world has been tragically altered, as the haunting artwork in this book demonstrates. While we have been increasingly vigilant about our nation's security needs, we must not lose sight of the needs of our children. We must honor the parents, teachers, childcare providers, and others who comfort and educate our children every day. These individuals, along with our nation's firefighters, police, and military, are true national heroes. The work of the young artists shown here is a testament to the resilience of our children; it serves as a reminder that the greatness of America is measured not just by the might of her military, but by the strength of her communities and the health of her children. ▪▪▪

hank you for helping N.Y.C
I ♥ The firefighters
god bless America

Peace

by Rachel Blankfein

| Rachel Blankfein, 8 years old. **Untitled.** 8 ½x 11"

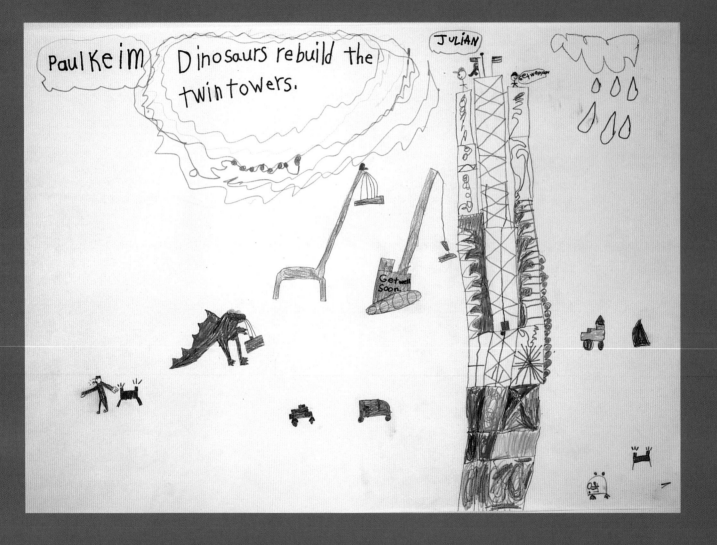

| Julian Cortez, 7 years old; and Paul Keim, 8 years old. **Untitled.** 24 x 36"

"The dinosaurs, the policeman, the doctors and the construction workers are building the new World Trade Center. The people at the top of the building are telling the people who lived to get well soon."

| Lisa Franklin, 9 years old. **No Planes Zone.** 18 ⅛ x 24"

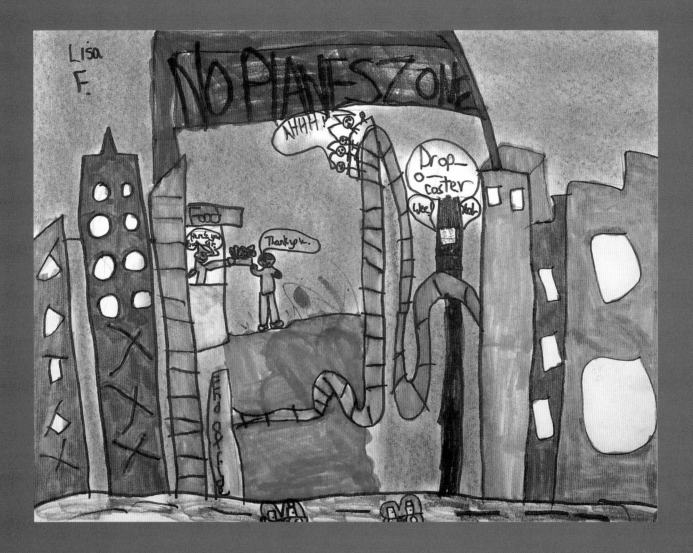

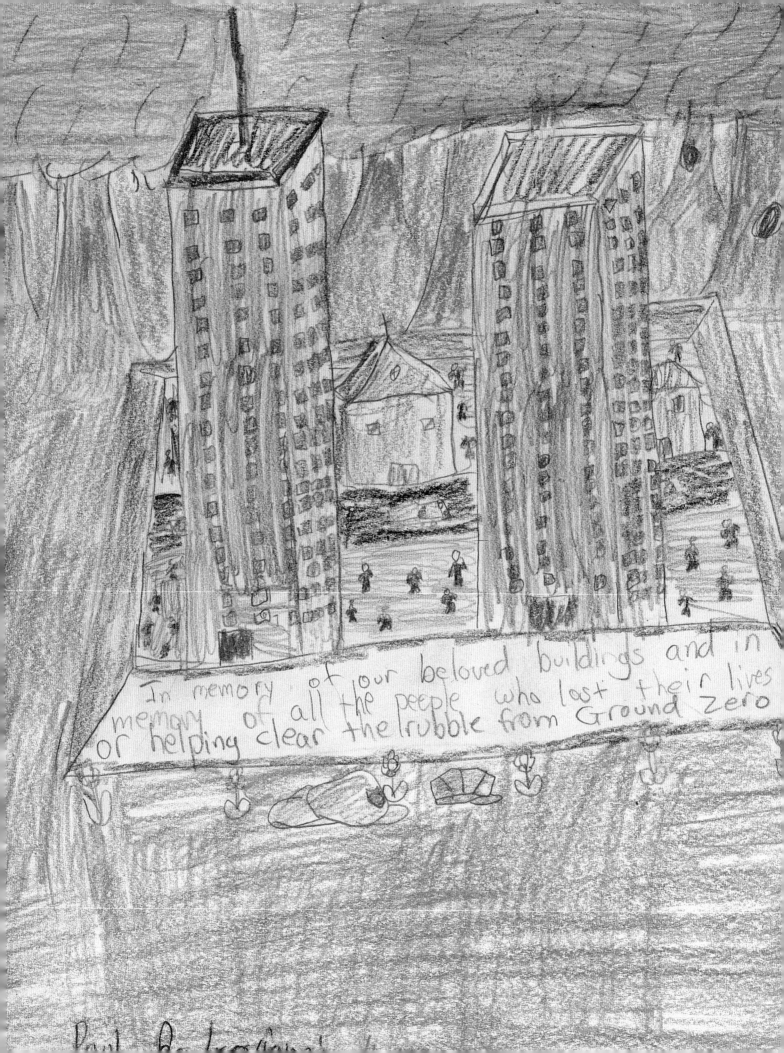

In memory of our beloved buildings and in memory of all the peeple who lost their lives or helping clear the rubble from Ground Zero

A Foundation for a New America

IMAM ABDUL MALIK

Life and death are both parts of the human experience. There is no way to know life without death; they are two sides of the same reality. September 11, 2001, has reminded us of this universal truth. On that day, some lived and died without knowing their purpose; others struggled to save the lives of their fellow citizens. They all died fulfilling their higher calling. Many gave their lives so others may live in freedom.

The impact of this great trial on the hearts and minds of our children has created many different reactions. Some of our children are living in fear, confusion, and anxiety. Some are in a psychological coma created by shock, wondering if this really happened. Other children, however, have found a new meaning in their lives. These children have transformed their minds. They decided that the forces of evil would not conquer them. They are born-again heroes without fear, but with faith in the goodness of humanity. They are inspired by the unified response of the love, support, encouragement, giving, and sharing of the American people and the world community. They have a vision that the dry bones in the valley will rise again. They see the World Trade Center ashes as a foundation for a new America. They recognize that the men and women who died are our true martyrs: they gave their lives that we may live. Finally, the children have quietly made a pact with the force of life, that they will devote their own lives one day to benefit their fellow citizens, if the trumpet of service is blown. God bless our children. ■■ ▮▯

| Paul Bakoyiannis, 9 years old. **Model of World Trade Center.** 8 ½ x 11"

"If I was an architect asked to rebuild Ground Zero, I would suggest to build a park with a memorial."

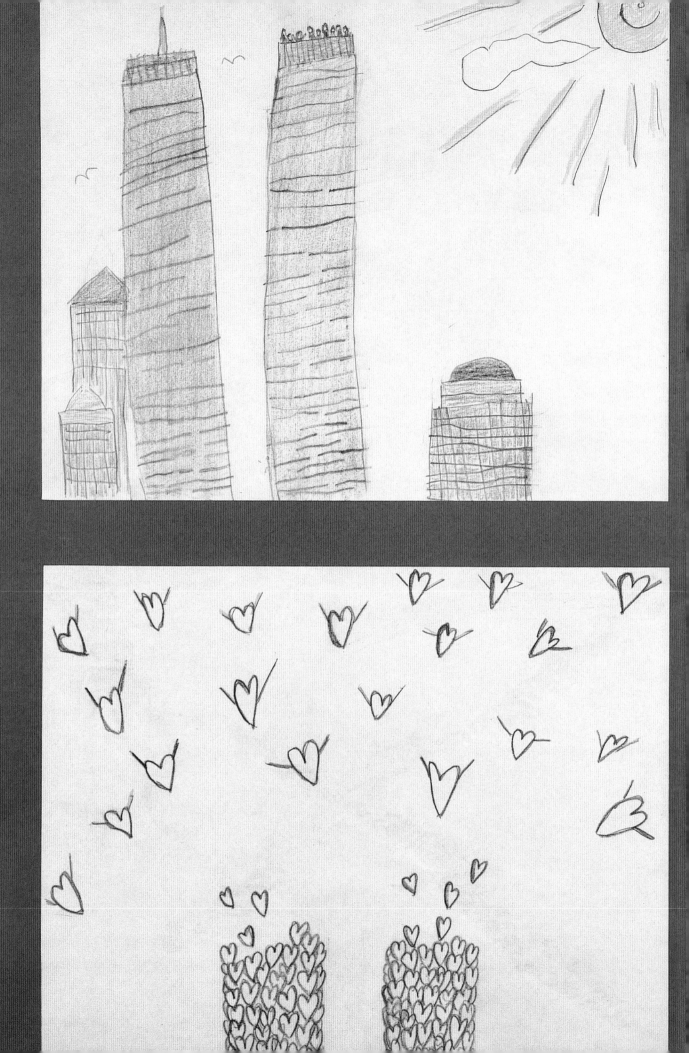

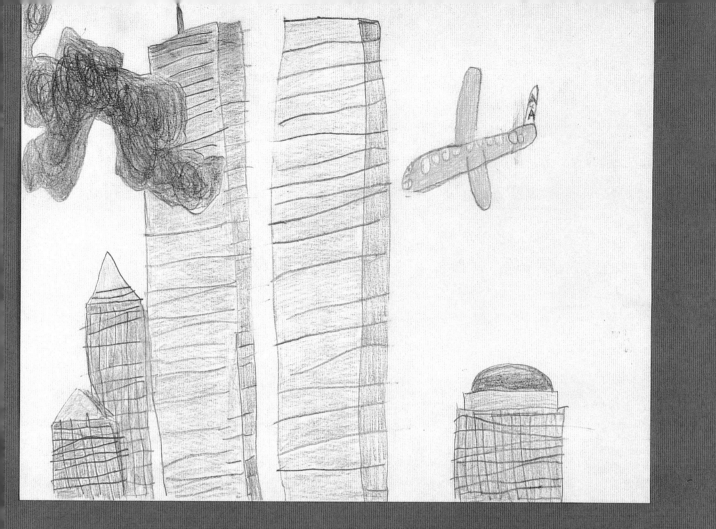

| Kevin Wang, 8 years old. **Untitled.** 22 x 27 ⅞"

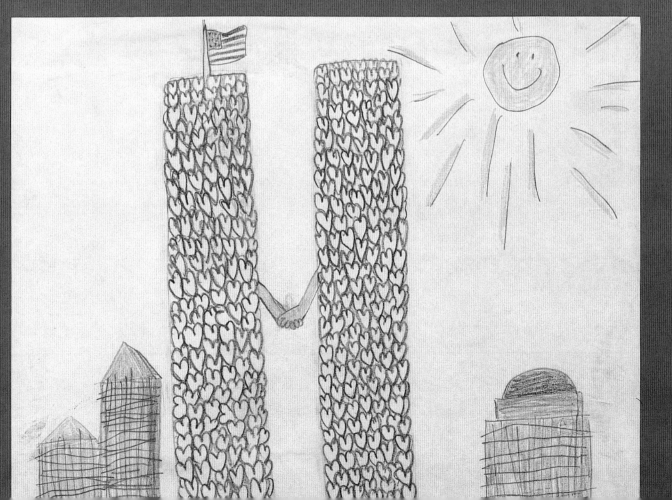

Stronger & More United than Ever

GOVERNOR GEORGE E. PATAKI

The morning of September 11, our children went to school with wide eyes, curious grins, and unbridled laughter. By the end of that day, our children were faced with a world that was changed forever.

The events of that Tuesday morning changed our lives and continue to challenge all generations of New Yorkers. Thousands of fathers and mothers and sisters and brothers were lost. Our great city's skyline was altered forever. Innumerable hearts were broken.

As adults, we struggle to understand how this horrific event happened and why such feelings of hatred even exist. At the same time, we know that we must embrace and educate our youth about the good that shone through in the face of this evil.

Out of the devastation of September 11 emerged the tremendous and irrepressible spirit of New Yorkers—a spirit of resilience, compassion, and courage. And because it affected each of us, this tragedy strengthened our communities. New Yorkers came together as never before—as families, friends, colleagues, neighbors, and even as strangers. In fact, we became one family, unified by tragedy and joined forever for our children.

We have a responsibility to support our children. This responsibility includes filling their hearts with strength and confidence to face the future. We must let them know that lives were not lost in vain, and even though we will never forget, our hearts will heal, and our future will be bright.

I have received thousands of letters from children from all around the globe. Every letter shares a piece of a child's grief and honest confusion. In responding to these letters, I find myself confronted by the same emotions. Yet I am hopeful, knowing that our next generation will be more emotionally prepared to meet the challenges that rise before them.

The artwork in this book reminds us that our children must be active participants as we search for answers during this confusing time. As Americans, we have a duty to make sure our children's hopes and dreams never waiver, for they are our future leaders in government, industry, education, and the arts. For the sake of these young and energetic New Yorkers, we must strive to give all our youth the best possible support in life.

These images of America's most tragic day provide other children with an opportunity to heal from this horrific injustice, and they encourage families to channel their own children's emotions and feelings appropriately. And about this there can be no doubt: New York, united in purpose and steeled with resolve, will emerge from this tragedy stronger and more united than ever. ▪ ▬

| Jason Rodriguez, 17 years old. **State of Confusion.** 13 ⅞ x 16 ⅞"

"My drawing is of a hand gripping America. This expresses the U.S.A.'s strength and ability to shine (even after the circumstances of the WTC)."

| Katie Profusek, 17 years old. **Squeezing of America.** 23 ⅜ x 18"

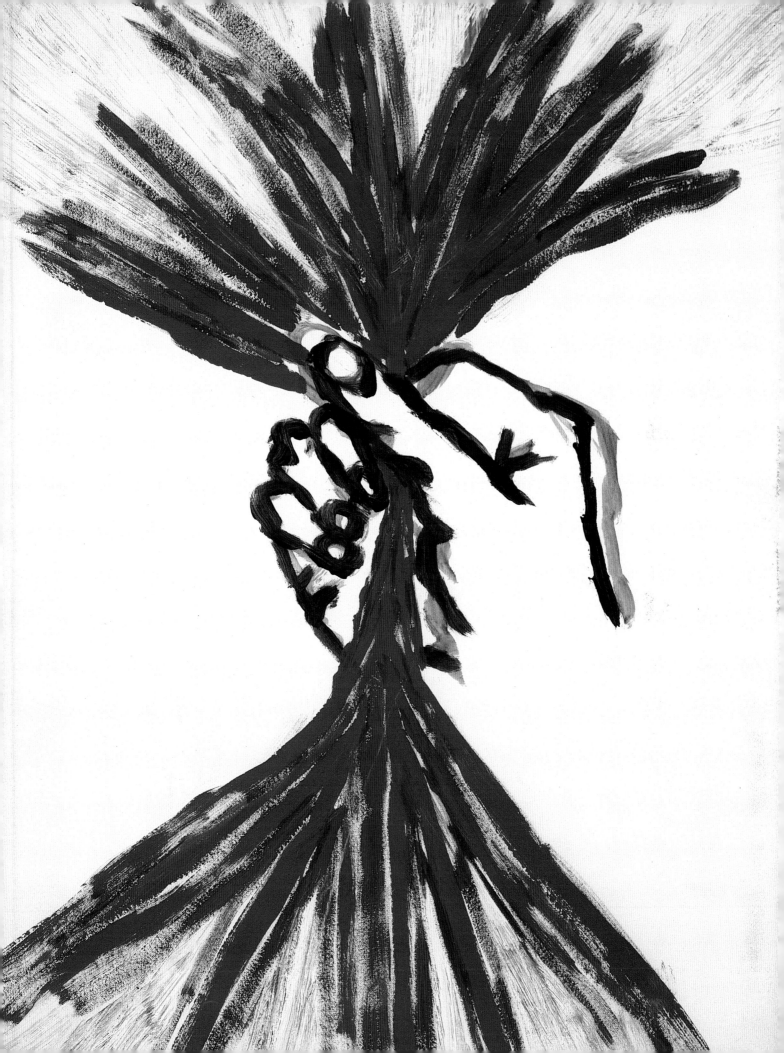

CONTRIBUTING SCHOOLS AND TEACHERS

The page numbers following some of the contributors identify artwork in this book that was made by students at that specific school. A complete exhibition of the artwork, containing additional submissions, can be found at **www.TheDayOurWorldChanged.org**

Abraham Joshua Heschel School, New York, Robin Lentz (teacher): 96-7

The Active Learning Prep School, Rockaway Beach, N.Y., Elizabeth Castellano (teacher)

Archdiocese of New York, James Simone (Associate Superintendent, Special Education)

Bishop Kearney High School, Brooklyn, Sister Mary P. Hurley and Jane Plaut (teachers): 66, 91

Board of Jewish Education, New York, Rabbi Ellis Block (Director, Yeshiva Day School Department), Temima Gezari (Art Director Emeritus), Judy Oppenheim (Director, Government Relations), and Rabbi Martin Schloss (Director, Division of School Services)

Brunswick School, Greenwich, Conn., Sherry Tamalonis (teacher): 27

The Caedmon School, New York, Mary Moross (teacher)

The Child School, New York, Leslie Baldini and Mary Jane Hanja (teachers): 113

Christopher Columbus Middle School, Clifton, N.J., Courtney Matonti and Cortlan McManus (teachers)

Crispell Middle School, Pine Bush, N.Y., Linda Higby and Patricia Moore (teachers): 47, 60, 61, 62, 63

The Dalton School, New York, Dianne Orkin Footlick and Linda Hanauer (teachers): 1, 18-23, 54, 85 (top), 105

De LaSalle Academy, New York, Oshan Temple (teacher): 114

Ethical Culture Fieldston Lower School, Bronx, Diane Churchill and Corinne Farkouh (teachers): 84-5

Gifted & Talented Academy for the Arts & Sciences at Intermediate School 59Q, Springfield Gardens, N.Y., Sharon Dobson-McClinton (teacher)

Grace Church School, New York, Carol Collet (Assistant Headmaster), Catherine DeVuono and Steven Montgomery (teachers): 59, 92-3, 108, 119

Greenwich Academy, Greenwich, Conn., Sherry Tamalonis (teacher): 24, 32-3, 35, 67, 125

Haledon Public School, Haledon, N.J., Carol Ann Benson and Susan Cassisi (teachers), 38-9, 48

The Hoboken Charter School, Hoboken, N.J., Sue Malkemes (teacher): 118

Hungerford/Public School 721R, Staten Island, Linsey Miller (teacher)

The International School at Dundee, Riverside, Conn., Ferris Buddy (teacher) and Douglas W. Fainelli (Principal)

Intermediate School 77Q, Ridgewood, N.Y., Linda Cardillo (school psychologist)

Junior High School 157, Rego Park, N.Y., Mario Asaro (teacher): 64-5

Kinneret Day School, Bronx, Barbara Pato (teacher)

Leptondale Elementary School, Wallkill, N.Y.: Amelia Gallagher (teacher): 109

Louis Pasteur Middle School 67Q, Queens, Anthony Ingoglia (teacher): 69, 70, 72

Middle School 821–Sunset Park Prep, Brooklyn, Cynthia Stylianou (teacher)

Middle School 827 New Voices, Brooklyn, Anna Commitante (teacher): 87

Murry Bergtraum High School for Business Careers, New York, Margaret Boutin, Irene Buszko, and Gail Reisin (teachers): 25, 44-5, 55, 79, 80, 101, 106, 112, 124

New Canaan East Elementary School, New Canaan, Conn., Michelle Zacchia (teacher): 82-3, 86

New York City Art Teachers Association, New York, Joan Davidson (President)

Ostrander Elementary School, Wallkill, N.Y., Connie Noelle (teacher): 4, 36-7, 49, 52

O. T. C.– Public School 721X, Bronx, Hope Danville Quinlan (teacher)

Our Lady of Angels School, Brooklyn, C. Yorio (teacher): 56

Our Lady Queen of Martyrs, Forest Hills, N.Y., Sheila Smith-Gonzalez (teacher): 122-3

Public School 1, Brooklyn, Jackie Cruz (teacher): 31, 50-1, 78

Public School 4-843, Brooklyn, Erica Levine (teacher)

Public School 23Q Hillside / Long Island Jewish Medical Center Hillside Hospital, Glen Oaks, N.Y., Judith Harouche (teacher)

Public School 31, Bronx, Maryann Manzolillo (teacher)

Public School 87, New York, Andrea Schwartz (speech & language pathologist)

Public School 96Q, South Ozone Park, N.Y., Remona Boodoo (teacher): 26, 76

Public School 111/Adolph S. Ochs School and Academy, New York, Amy Duquette (teacher)

Public School 254/Project Arts, Brooklyn, Francia Tobacman (teacher)

Public School 277, Brooklyn, Maryjane Wisniewski (teacher)

Saint Joseph's School for the Deaf, Bronx, Adrianne Grant and Isabel Ring (teachers)

Saint Therese of Lisieux School–Little Flower School, Brooklyn, Nelly Acevedo (teacher)

School 30, Yonkers, N.Y., Cheri Uberman (teacher): 88-9, 95 (top)

Solomon Schechter Day School, Jericho, N.Y., Marianne Halpern, Amanda Shyman, Rebecca Singer, and Sandi Swerdloff (teachers): 42

Somerdale Public School District, Somerdale, N.J., Carmen Bayard (teacher): 53

Terryville Road School, Port Jefferson Station, N.Y., Cheryl Singer (teacher)

Washington Irving High School, New York, Jack DeMartino and Bonnie Goodman (teachers): 74, 75

William Spyropoulos School, Flushing, N.Y., Antigone Vlachoyannis-Olinski, Ph.D. (teacher): 3, 120-1

Yeshiva Merkaz Hatorah, Staten Island, Pirchi Alpert (teacher): 41

Yeshiva of Flatbush, Brooklyn, Elise T. Goldberg (teacher)

BIOGRAPHIES OF CONTRIBUTING WRITERS

Debbie Almontaser is a teacher, curriculum writer, and multicultural-education specialist in the New York City public schools in Brooklyn. She conducts workshops on Arab culture and Islam at libraries, museums, universities, churches, and synagogues across the city.

Arthur L. Carter is the Founder and Publisher of the *New York Observer*. He has taught in the philosophy and journalism departments of New York University and has exhibited his bronze and steel sculptures at galleries in New York and Paris.

Senator Jon S. Corzine is the junior United States Senator from New Jersey. He was formerly co-Chairman and co-Chief Executive Officer of Goldman Sachs.

Reverend Alan Gibson is an Episcopal Priest and Rector of All Saints' Church in Navesink (Middletown Township), New Jersey.

Robin F. Goodman, Ph.D., A.T.R.-BC, is Director of Bereavement and Outreach Services, AboutOurKids.org, and Public Education Programs at the New York University Child Study Center. She has published and lectured nationally on children, art, parenting, illness, and death and has a private psychology and art therapy practice in New York City.

Pete Hamill is a native New Yorker, a veteran newspaper columnist, and the author of fifteen books, including a biography of the painter Diego Rivera and eight novels.

Sarah M. Henry, Ph.D., is a historian and Vice President for Programs at The Museum of the City of New York. She specializes in the history of reform and the effect of war on American society.

Imam Abdul Malik is the Official Chaplain for the Metropolitan Transit Authority Police Department and a guest Imam and lecturer for many cultural centers throughout the United States and Canada.

Lieutenant Victor J. Navarra is a retired New York City firefighter. He served at Ladder 35 FDNY, located at Sixty-sixth Street and Amsterdam Avenue.

Governor George E. Pataki is the Governor of the State of New York.

Tim Rollins is Founder and Director of Tim Rollins and K.O.S. ("Kids of Survival"), a collaborative team of young artists started in 1981 in the South Bronx. Rollins currently works with teams of kids in New York, San Francisco, and Memphis and also conducts art workshops with young people throughout the world.

Jane Rosenthal, President of Tribeca Entertainment, is a movie and theatrical producer. **Craig Hatkoff** is Chairman of Turtle Pond Publications and is active in children's publishing and entertainment. Jane and Craig are co-Founders of the Tribeca Film Festival.

Rabbi Peter J. Rubinstein is the senior Rabbi of Central Synagogue of New York City.

Senator Charles E. Schumer is the senior United States Senator from New York. He is a product of the Brooklyn public schools.

BIOGRAPHIES OF ART JURORS

Lisa Pevaroff Cohn serves on the Child Study Center's board of directors. She is also a painter and the mother of three young children.

Miriam de Uriarte is the former Director of Education at the Museo del Barrio in New York. She now serves as the Director of the San Francisco Museum of Craft and Folk Art.

Andrea Henderson Fahnestock is Curator of Paintings and Sculpture at The Museum of the City of New York.

Robin F. Goodman, Ph.D., A.T.R.-BC, is Director of Bereavement and Outreach Services, AboutOurKids.org, and Public Education Programs at the New York University Child Study Center. She has published and lectured nationally on children, art, parenting, illness, and death and has a private psychology and art therapy practice in New York City.

Diana Horowitz is a painter, an award recipient from the American Academy and Institute of Arts and Letters and the Pollock-Krasner Foundation, and a fellowship receipient from Yaddo and the MacDowell Colony. She is represented in many museum collections.

Ashfaq Ishaq is Executive Director and Founder of the International Child Art Foundation and Editor of Child Art magazine.

Whitney Scott is a senior at the High School for Arts and Business in Corona, Queens.

Linda Sirow is a painter and teaches art to grades four through eight at The Dalton School in New York City.

The New York University Child Study Center and The Museum of the City of New York are using all proceeds from this book to continue their educational, clinical, and research activities related to the aftermath of September 11.

PROJECT MANAGER: Eric Himmel
EDITOR: Gail Mandel
ART DIRECTOR/DESIGNER: Michael J. Walsh Jr.
PRODUCTION DIRECTOR: Hope Koturo

Library of Congress Control Number: 2002104747
ISBN 0-8109-3544-9

Printed and bound in Hong Kong
10 9 8 7 6 5 4 3 2 1

Harry N. Abrams, Inc.
100 Fifth Avenue
New York, N.Y. 10011
www.abramsbooks.com

Abrams is a subsidiary of
LA MARTINIÈRE
GROUPE

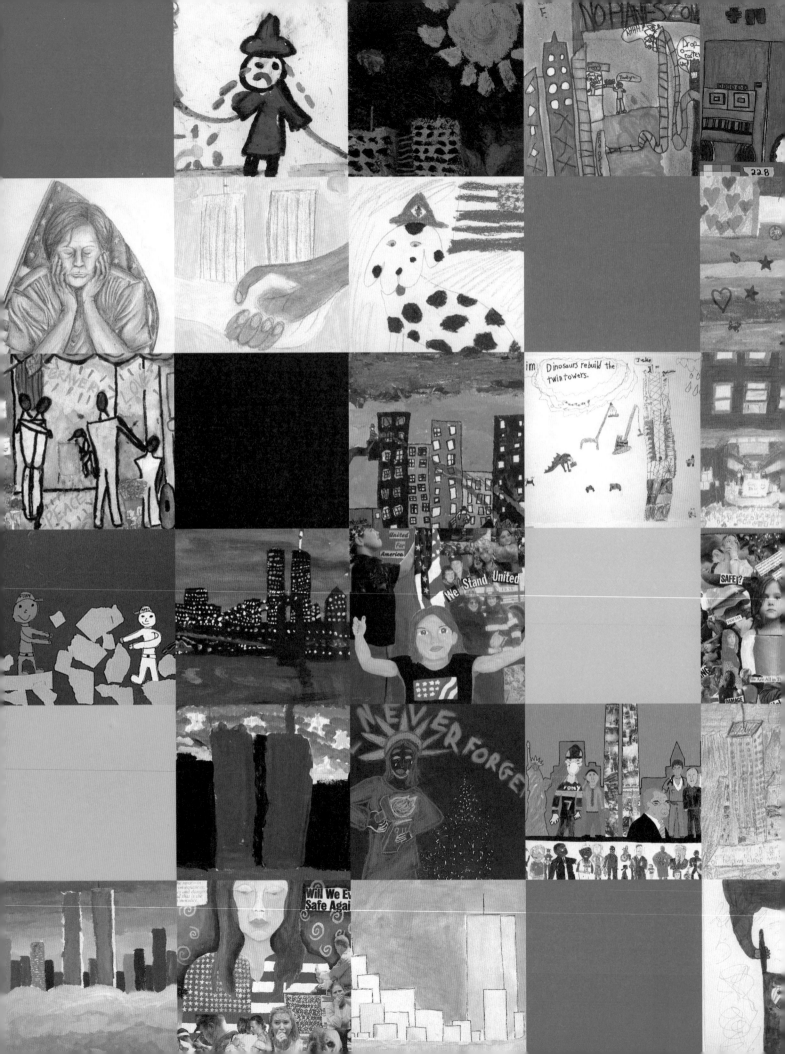